COSMIC TRIP

ROCK CONCERTS AT THE
MINNEAPOLIS
LABOR TEMPLE
1969-1970

CHRISTIAN A. PETERSON

POSTER ART BY JURYJ (GEORGE) OSTROUSHKO

RESEARCH ASSISTANCE BY PAUL PASHIBIN

SMART SET • MINNEAPOLIS

COSMIC TRIP

Rock Concerts at the Minneapolis Labor Temple, 1969-1970

Posters by Juryj Ostroushko
Text by Christian A. Peterson
Research Assistance by Paul Pashibin

Layout and Design by Kevin Brown, Smart Set, Inc.
Art Direction by Juryj Ostroushko
Liquid light show images courtesy of Wet Sun Light Show:
Phil Hazard, John Ferns, and Patricia Swemba

Printed and published by Smart Set, Inc.
1209 Tyler Street NE, Minneapolis, Minnesota 55413
www.smartset.com
First edition | Second printing
ISBN: 978-0-9984844-4-0
2021

Distributed by the University of Minnesota Press
111 Third Avenue South, Suite 290
Minneapolis, Minnesota 55401-2520
www.upress.umn.edu

FOREWORD

It was May of 1969, what a year! Canned Heat had two records on the charts: "On the Road Again" and "Going Up the Country." In a few months Woodstock would happen, and we were America's number one band.

So, we found ourselves in this "Labor Temple," and we were ready to have some fun and share with the audience. This was the classic Canned Heat line-up, with Bob "The Bear" Hite, Alan "The Blind Owl" Wilson, Henry "The Sunflower" Vestine, Larry "The Mole" Taylor, and myself. The shows we played that year were exceptional—we were at our best in the best of times. Yes, sometimes we played too long, but that was the thing to do in those days: a lot of improvisation and long solos. How great and how different from today's music that is so rigid and stiff. According to one Minneapolis reviewer, the promoter had to "pull the plug" on the band because we were playing too long, that is because we were having so much fun, as was the audience!

Minneapolis has always been a good place for us to play. We came back several times, but we never had that especial "Vibe" that only happened in that particular year and in that place. "The Labor Temple" was a remarkable venue, never to be forgotten. Boogie on . . .

Adolfo "Fito" de la Parra
Drummer for Canned Heat
2018

INTRODUCTION

From February 1969 to November 1970, an unprecedented series of music shows was presented at a stately building in Southeast Minneapolis, known as the Labor Temple. Nearly 50 weekly dance concerts, modeled after those at San Francisco's Fillmore Auditorium, took place in the Temple's ballroom, which was acoustically sound and accommodated about 1,250 people. This group of Minneapolis shows was one of a handful of similar sets of performances that occurred around the country, in cities such as Detroit and Seattle.

The concerts here usually featured leading internationally known American acts like the Grateful Dead, the Youngbloods, Johnny Winter, and the Byrds, along with English musicians such as Savoy Brown and the Jeff Beck Group. Opening acts generally were drawn from the rising tide of local musicians, such as Jokers Wild and the Mojo Buford Group. Numerous genres of music were showcased, including rock, rhythm and blues, folk, and country. Psychedelic light shows accompanied the events, as did a hazy atmosphere of marijuana smoke.

An essential element to these concerts were the accomplished, colorful posters designed by Juryj Ostroushko, a budding commercial artist who had grown up in Northeast Minneapolis, just blocks from the Labor Temple. Ostroushko, who was aware of the San Francisco psychedelic posters, appropriated images from published sources, rendered his own illustrations, and hand-lettered typography that was intentionally difficult to read (to simulate the effects of recreational drugs). The posters were printed in small quantities and, as usual, affixed to telephone poles and taped inside shop windows, but rarely kept, making them scarce today.

Presently, few people, either locally or nationally, know about these concerts and their accompanying visual advertisements. Nonetheless, they form a vital chapter in the long and rich history of Minnesota music and greatly deserve recognition, documentation, and interpretation. This publication attempts to rectify this situation, and consists of two main chronological sections. The first comprises an overview essay about the Labor Temple as a venue, how and who ran it, and the nature of its concerts. The second section features information on each particular show and its corresponding poster or other form of promotion, such as handbills or newspaper advertisements (when no poster was produced). For easy reference, an index to all of the musicians mentioned in the text closes the book.

COSMIC TRIP

MINNEAPOLIS LABOR TEMPLE 1969-70

POPULAR MUSIC IN THE
TWIN CITIES BEFORE 1968

Blues and rock'n'roll music came to Minnesota long before the Labor Temple commenced its shows in the late sixties. On April 25, 1958, for instance, promoter and disc jockey Alan Freed brought to the Minneapolis Auditorium his "Big Beat" show of 17 groups, including Buddy Holly and Chuck Berry. Two years later Elvis Presley played the same venue. In 1960, Bo Diddley performed here, and over the next few years Minneapolis also experienced Chubby Checker, Bill Haley and the Comets, Muddy Waters, the Beach Boys, and the Kingsmen.

In November 1963, Minneapolis' own Trashmen released their garage-surf single "Surfin' Bird," which sold briskly, rose to the top of national charts, and garnered them a West-Coast tour as headliners. A few years later, local booking agent Dick Shapiro declared that the Twin Cities was home to over 250 bands capable of playing the popular dances regularly held for teenagers. Among these groups was the Castaways, whose 1965 novelty hit "Liar, Liar" charted internationally.

Minneapolis sprouted not only performers, but also competent recording studios, record labels, and radio stations and personalities. On the edge of the University of Minnesota, a thriving folk and blues scene emerged. Soon-to-be staples were Tony Glover, "Spider" John Koerner, Willie Murphy, and Dave "Shaker" Ray, who played the Viking and Triangle bars, Riverside Café, Coffeehouse Extempore, and the Scholar. Bob Dylan also participated briefly, when he attended the university (1959-1960), before decamping for New York.

In the mid to late-1960s many international rock acts descended on the Twin Cities with their new, electrified sound. Among them in 1964 were the scruffy Rolling Stones and the polished Dave Clark Five. Undoubtedly the highpoint was on August 21, 1965, when John, Paul, George and Ringo, played before 25,000 screaming youngsters (as Ed Sullivan liked to call them) at the Metropolitan Stadium, an outdoor sports facility in the suburb of Bloomington. Appearing in Minneapolis the same year were the Zombies, Herman's Hermits, and the Temptations. The years 1966 and 1967 were well packed with concerts, by the likes of the Animals, Supremes, Yardbirds, Turtles, Jefferson Airplane, Buffalo Springfield, Shadows of Knight, Monkees, and the Who. During this period, Twin-Cities teens and college students enjoyed a rich selection of live music, being exposed to, among other genres, psychedelic music from San Francisco and blues rock from England. All this was the perfect preparation for the beginning of an underground, hippie movement right here in Minnesota.

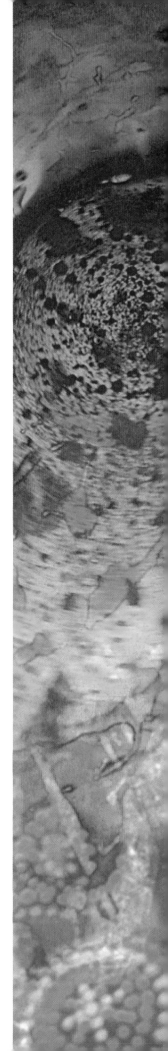

DANIA HALL, 1968

In early 1967, Charlie Campbell and Jim Donnelly, two close friends just a few years out of high school, hitchhiked from Minneapolis to San Francisco, ground zero for the American counterculture movement. There, individuals gathered to form a community committed to progressive attitudes toward sex, drugs, music, race, art, spirituality, and the environment. Particularly drawn by the Bay Area's psychedelic music, Campbell and Donnelly soon found themselves apprenticing with Magic Theater Lights, an offshoot of Ken Kesey's Merry Pranksters who illuminated rock concerts with colorful, moving projections. Based a little south of San Francisco, in Palo Alto, Donnelly and Campbell also spent time with the Grateful Dead's lyricist, Robert Hunter.

While the Spring of 1967 was euphoric in the Bay Area, by the middle of the "Summer of Love" the city was bulging with young runaways and freeloaders who taxed local services and merchants. Marijuana and LSD gave way to hard drugs, overdoses, and related crime; free love led to widespread venereal disease. Fed up, Campbell and Donnelly hitched back home in the Fall of 1967, anxious to be the first purveyors of light shows in the Twin Cities.

Campbell took a job to earn enough money to buy the necessary equipment for a basic light show, most importantly two overhead projectors. Once these were secured, the pair presented their first display at the university's Coffman Memorial Union for a concert by the band High Spirits. But to their surprise, neither the musicians nor the audience fully appreciated the light show and they had trouble securing additional gigs.

So Donnelly and Campbell decided to take matters into their own hands. They noticed an old, four-story building near the university, named Dania Hall, which was available for rentals. Built in 1886 and located on the corner of Cedar Avenue and Fifth Street (one block south of Riverside Avenue), Dania Hall originally was a community center for Danish immigrants. In 1968, the first floor was occupied by the Richter Drug Store, the second story comprised apartments, and the third and fourth floors housed a small, but ornately designed ballroom. The stage had intricately carved wood, an original gas chandelier hung above the floor, the arched proscenium was topped with a fancy curtain, and the balcony sported a dramatically curved railing, behind which were about one hundred permanent wooden chairs. One regular attendee called Dania Hall, which had a capacity of about 500 people, "the venue of choice for any band."[1] Since Campbell and Donnelly couldn't get bands or promoters to hire them, they decided to become the concert organizers, finding the groups and then providing the lights shows.

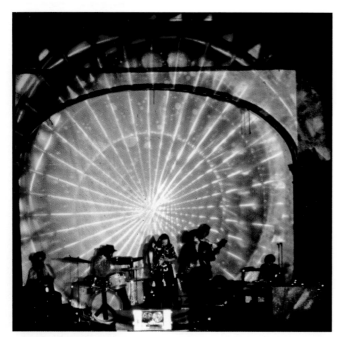

1. Light show, Dania Hall, Cold Duck performing, 1968. Courtesy of Charlie Campbell.

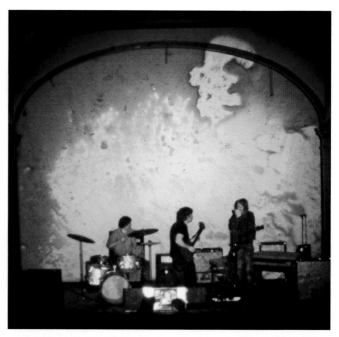

2. Light show, Dania Hall, Mill City Blues Band performing, 1968. Courtesy of Charlie Campbell.

According to Campbell, these light shows, which were seen on a screen behind the band, included layered, liquid projections, cartoons, slides, and art films checked out from the public library. "We would blend all of the above in and out to the beat of the music to produce an hallucinatory effect" (fig. 1 and 2).

What was probably their first concert at Dania Hall occurred on April 14, 1968, Easter Sunday. The poster announcing the show declared "Community News Does Lites Easter Night" (fig. 3). The featured bands were Noah's Ark and T.B.I. (True Blues, Inc.), both of whom became regulars at the venue. The name Community News (inspired by a regular feature on a local radio station) was what Donnelly and Campbell adopted for their promotional and light show undertaking. Shows at Dania Hall did not have chairs (except in the balcony), allowing audience members to sit and recline on the floor, move with the music, and mill around at will. This free form setting encouraged those in the crowd to intermix with each other and connect with the musicians as they performed.

Like in San Francisco, young people in the Twin Cities during the 1960s began to rebel against straight, middle-class society by embracing new music, unusual clothing, progressive politics, and peaceful human interaction. The shows at Dania Hall were so eye-opening that even the off-duty, city policemen who provided

security for them were impressed. Officer Donald Reynolds told the Minneapolis Star, "They're a group apart alright. You should see them Friday and Saturday nights. Three or four hundred come, and they wear costumes—rebel outfits, hats, and weird coats. But these dances, with as many kids as there are, are less trouble than I've ever had bouncing bars."[2] Minneapolis now had its own community of long hairs and hippies who lived by the ideals of "peace, love, and understanding."

Community News and other organizers shared Dania Hall during 1968, presenting shows somewhat sporadically until the Fall. Among the bands known to have played there were Poison Bird Pie, Mill City Blues Band, T.C. Atlantic, Cold Duck, and Pandemonium Side Show. The Paisleys, a self-described "love-rock" quartet, performed with their own lights (run largely by Gary Dale), and organized "happenings" that included the participation of the audience, vocally, musically, and physically. Another outfit, called the East India Trading Company, also competed with Community News as a light show provider.

At this time, Campbell held down a day job at an alternative shop called Leatherhead. The Dania Hall shows provided little income, with Community News and the musicians evenly splitting the meager profits. Among Leatherhead's customers was Juryj Ostroushko, a recent graduate of the graphic design program at

the Minneapolis Vocational-Technical High School. Separately, Ostroushko had also visited San Francisco in 1967, flying out with a friend who bought him an airline ticket. Naturally, he attended dance concerts at the Fillmore Auditorium and Avalon Ballroom, and he was most impressed by the accompanying posters designed by Rick Griffin and Stanley Mouse. Campbell and Ostroushko did not cross paths in California, but back in Minneapolis they met at Leatherhead. This lead to Ostroushko designing a poster for the shop and subsequently handbills and posters for some of the Community News shows at Dania Hall. Ostroushko usually carried a sketchbook around with him, drawing when he saw things of interest or when inspired by a visual idea, and some of these sketches became the basis for posters that he later designed. He recalls that for many of his hand-rendered illustrations he would make a few preliminary, pencil sketches before produc-ing the final version in ink.

In late 1968, Community News presented concerts there more regularly, with at least five in October, November, and December. Ostroushko's first poster for Dania Hall promoted the October 19 show by the strangely named Nicollet Island Peep Show (fig. 4). This quartet's music was later described as "very loud sheets-of-sound solos that anticipated heavy metal by at least five years. It was the spirit of 'Turn up the amps and blast it out!' that symbolized the era."[3] At the time, Ostroushko worked at a graphic design shop named Headliners, where he had access to typefaces, stock borders, and dingbats, which he used to create the poster for the show. Interestingly, "Dania Hall" appears in type larger than that of the band's name. For these two words, he utilized the typeface Epoque, an Art-Nouveau inspired font designed by Headliners that he would use regularly in later posters for the Labor Temple. The squiggly dingbat shapes he chose mim-icked the liquid nature of the light show that accompa-nied the night's music.

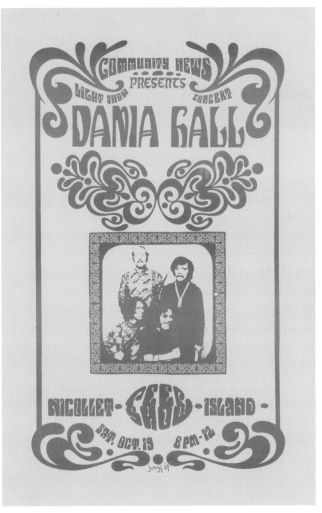

3. Poster by Bob Klock. Dania Hall, Noah's Ark, April 14, 1968. Courtesy of Jim Donnelly.

4. Poster by Juryj Ostroushko. Dania Hall, Nicollet Island Peep Show, October 19, 1968.

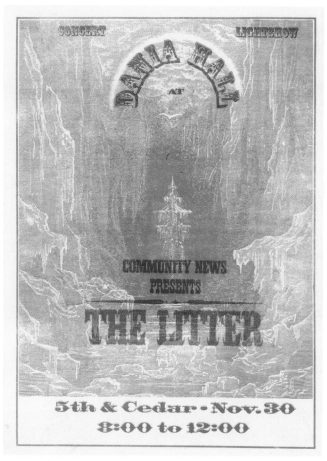

5. Poster by Juryj Ostroushko. Dania Hall, Litter, November 30, 1968.

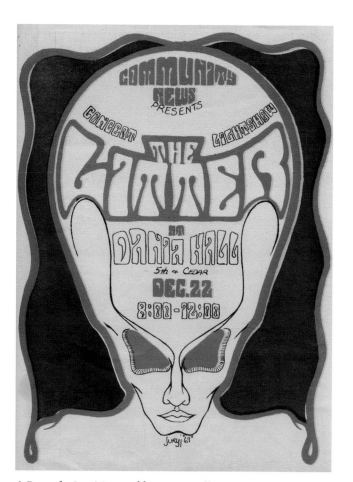

6. Poster by Juryj Ostroushko. Dania Hall, Litter, December 22, 1968.

Subsequent Dania Hall shows included those on November 30 (fig. 5) and December 22 by the Litter, a leading local psychedelic/garage band that had already released two albums. Ostroushko's poster for the December Litter concert was completely hand drawn and was the most successful of those he designed for Dania Hall (fig. 6). It features an alien's oversize head, which encapsulates all of the poster's lettering. Here, Ostroushko played with negative/positive space by enclosing the background in a sinuous border. The artist, at the time, was inserting just his first name in his works (seen here, below the alien's chin), curiously conjoined with "69," even though the year of the poster was 1968, not 1969.

The last concert that Community News hosted at Dania Hall was on December 29, 1968, with Jokers Wild, another successful local rock band (fig. 7). Over the previous year, the band had included up to five members, but in the Summer it pared itself down to a power trio (the first in the Twin Cities) comprised of Lonnie Knight (guitar and lead vocals), Denny Johnson (bass and vocals), and Pete Huber (drums). They now created

a "wall of sound," emanating from stacks of Sunn amplifiers and speakers. Undoubtedly, the relatively small Dania Hall reverberated with high decibels during this end-of-the year concert, which was seen by a capacity crowd.

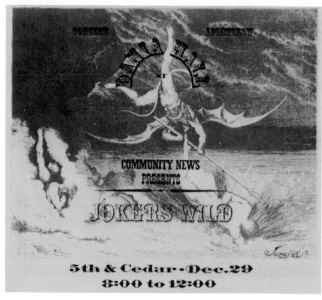

7. Handbill by Juryj Ostroushko. Dania Hall, Jokers Wild, December 29, 1968.

COSMIC TRIP

MINNEAPOLIS LABOR TEMPLE 1969-70

PRESENTED BY COMMUNITY NEWS AND DAVID ANTHONY, 1969

After the December 1968 concert by Jokers Wild at Dania Hall, David Anthony Wachter (who then went by David Anthony), Jokers Wild's manager, lamented that there was not a larger ballroom in the area with the same warmth and charm of Dania Hall. At the time, bigger venues were, in fact, hosting rock concerts, such as the Minneapolis Auditorium, but it was cavernous and acoustically poor, and the new Guthrie Theater, but it had permanent chairs and assigned seating.

Charlie Campbell heard Anthony's comments and told him that there actually was such a site. Shortly before, Campbell and company had contemplated moving to a larger facility, where they could start booking national acts. So, Charlie ventured to city hall to find all the local venues that were approved for concerts. This lead him to a four-story, brick building in Southeast Minneapolis, called the Labor Temple. Campbell met with the building's owners in an effort to secure its ballroom for concerts, but he was unsuccessful. Local musician Tony Glover recounted the situation: "Community News was made up of young men with long hair. Ergo they were evil, untrustworthy, and all the other preconceived nonsense that went with the cliché. So they couldn't rent the place."[4]

David Anthony, on the other hand, was older, clean-cut, and well-dressed. He was the perfect straight man to secure a deal with the Labor Temple officials, and that's what he did. Campbell and Anthony agreed that Community News would have a say in selecting the entertainment and be paid $500 a concert for promoting and running the concerts. Thus, the format for producing shows was established: David Anthony provided the financing, legal work, and professional persona, while the members of Community News oversaw posters, tickets, lights, sound, and other logistical matters.

The Labor Temple was built in 1924 as the Eagles Building, in the period revival style, with modest terra cotta (fig. 8). Situated at 117 Fourth Street Southeast, it was just north of both Nicollet Island and the Mississippi River, which runs along the north edge of downtown Minneapolis. The building was half a block off of Central Avenue and across the alley from what is now the Aveda Institute, a body wellness school. It housed a ballroom on the third and fourth floors that measured most of the building's 88-x-166-foot outside dimensions, with a balcony of about 400 wooden chairs. In 1942, an association of labor unions purchased the building, renamed it the Labor Temple, and established offices. During the 1950s, they rented the ballroom out for concerts by big bands and jazz and rhythm-and blues musicians, such as Duke Ellington, B. B. King, Ray Charles, Miles Davis, and John Coltrane.

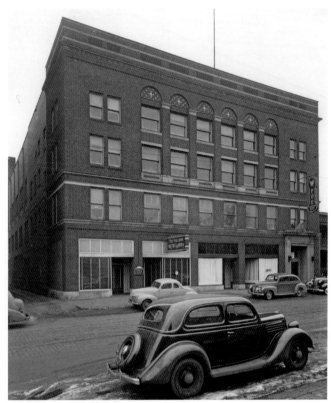

8. *Façade of the Labor Temple, 1940. Photograph by George Miles Ryan, collection of the Minnesota Historical Society.*

This musical legacy was revived by Community News and David Anthony in early 1969, when they began hosting rock concerts at the Temple. They moved with great speed, presenting their first show a mere five weeks after joining forces. On the sub-zero evening of February 2, 1969, the Temple opened its doors to a large crowd lined up to see none other than the Grateful Dead, the ultimate underground band from San Francisco. Attendees bought tickets at a booth (fig 9) not far inside the main, street-level entrance and then ascended two sets of stairs to the ballroom.

Anthony remembers the Dead as a "family of their own," showing up at the Temple with falcons, an iguana, rooster, goat, snake and three children. Having performed the previous two nights at Chicago's Kinetic Playground, they arrived late, with a tremendous amount of heavy equipment, consisting of their instruments, tube amplifiers, and large reels of cable, which had to be lugged up two flights of stairs. The Temple had an elevator, but it was too small to accommodate most musical equipment and was usually locked. Photographer Mike Barich recalled the Grateful Dead being very friendly and cooperative, when he photographed them backstage (fig. 10), although Phil Lesh

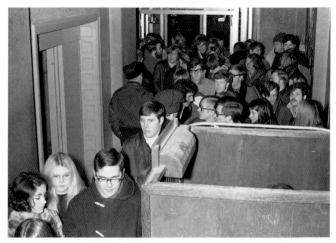

9. *Entrance to the Labor Temple, 1969, with ticket booth in foreground. Photograph by Mike Barich.*

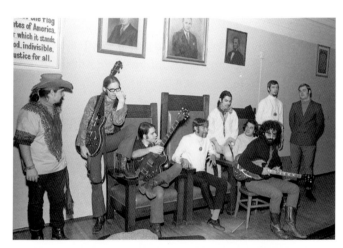

10. *The Grateful Dead, backstage. From left: Ron McKernan ("Pigpen"), Phil Lesh, Bob Weir, Tom Constanten, Mickey Hart, Bill Kreutzmann, Jerry Garcia, and two unidentified individuals. Labor Temple, February 2, 1969. Photograph by Mike Barich.*

stuck a finger up his nose. The show consisted of only nine songs, but ran to nearly an hour and half, thanks to two of them clocking in at over fifteen minutes each–"Dark Star" and "Turn on Your Lovelight."

The audience, comprised of high school and college students, long hairs, hippies, teeny boppers, and other young people, numbered around 2,000 that night. Unfortunately, this was beyond capacity, making the audience uncomfortably crowded. About the band, the Minneapolis Tribune reported, "Using some incredibly complex tempos and fine improvisations, they did the mixture of jazz and rock and folk that–along with the lights and, in some cases, marijuana–has been turning on people around the country for several years."[5]

Like at Dania Hall, the Labor Temple did not use assigned seating or even have chairs (other than those in the balcony), so that audience members could sit on

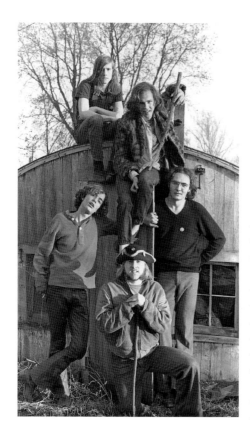

11. Members
of Community
News at farm
in Eden Prairie,
Minnesota,
1969. From top:
John Campbell,
Jim Hanson,
Jim Donnelly,
Joey Armstrong,
Charlie Campbell.
Photograph by
Mike Barich.

12. Community News logo.

13. David Anthony at the Labor
Temple, 1969. Photograph by Mike
Barich.

the floor, dance to the music, or otherwise gallivant about. After the Grateful Dead show, one newspaper gave the "New Rock Hall" a "Triple-A Rating," and another pointed out that it was perfectly suited for rock music, just as the university's stately Northrup Auditorium was to symphonic music.

By this time, the core of Community News numbered five individuals: the founders Campbell and Donnelly, joined by John Campbell (Charlie's younger brother), Joey Armstrong, and Jim Hanson (fig. 11). Hillary Kollins (now Stoltz) was also involved. Charlie remembers the group as something of an "urban tribe," and they produced buttons and t-shirts with the group's logo that was also, naturally, used on the concert posters (fig. 12). An illustration by Sir John Tenniel for Lewis Carroll's 1865 book "Alice in Wonderland" was the primary element for this logo. It shows the hookah-smoking cat-erpillar seated on a mushroom cap being observed by Alice, and also appeared (hand-rendered) on the Easter 1968 concert poster for the first show that Community News produced at Dania Hall (fig. 3). The poster artist Juryj Ostroushko joined Community News a little later and sometimes helped with the light shows.

Anthony and members of Community News held weekly meetings (usually on Monday or Tuesday) to agree upon musicians for upcoming shows, and John Campbell recalls that it was like being a kid in a candy

store, with the groups being the sweets. In their first such session, Anthony came with a list of bands that were available at the time, reading off Top-40 names such as the Buckinghams and Tommy James and the Shondells. It was only when he came to the very last possibility—the Grateful Dead—did the long hairs voice their approval. The promoters decided to present their weekly dance concerts on Sunday nights, for two strategic reasons. First, there were far fewer competing events that night, especially in contrast to Friday and Saturday evenings. And second, this encouraged groups who had played weekend shows in Chicago, to make the trip to Minneapolis, just as the Grateful Dead did.

David Anthony entered the Minnesota music scene in 1955 when he was in high school, running teen dances where he spun records on his own turntable. Two years later, at age 18, he established DA Enterprises, which booked bands and promoted music events. He managed the Trashmen early in their career, but was stationed in Korea in the U.S. military in 1963 when their hit "Surfin' Bird" broke. Upon returning to the Twin Cities a year later, he continued to promote music shows and manage bands, before hooking up with Community News in late 1968. He was a good negotiator (possess-ing the "gift of gab") and drove impressive cars (such as a red Ford Thunderbird). He appreciated fine clothing, wishing to project an air of taste, but, so dressed at Labor Temple concerts looked "completely out of place in his dark, banker-like vested suit" (fig. 13), according to one member of Community News. This was because the crowd was full of people in wild dress, as another means of expressing their youthful freedom.

The very day after the Grateful Dead concert, Community News met with residents of a hippie

mansion in St. Paul, to enlist their help with future shows. Campbell recalls that their inexperience and understaffing had created a kind of "mayhem" at the concert, a situation that he did not wish to repeat. Therefore, he enlisted volunteers to help with taking tickets, directing audience members, and selling concessions, in exchange for free entrance to the show. Security at the shows turned out to be a strangely shared responsibility. Anthony, not surprisingly, hired off-duty city police officers to handle the crowd on the first floor, inside the front entrance. They wore their uniforms and appeared sufficiently authoritative. He was required at first to have sixteen men on duty, but was allowed to reduce that number to only eight shortly thereafter, as there was no trouble. Community News, on the other hand, allowed members of the Hell's Angeles motorcycle club to monitor the crowd upstairs, as they sort of made their way in without being asked. Roughly attired, they blended in more with the hippie audience, but still could be menacing. Peter Ostroushko, Juryj's younger brother and now a recognized musician, recalls, as a 16-year old, being a little scared of this contingent, but never witnessed any confrontations.

The Labor Temple shows were promoted primarily in newspaper advertisements and by the posters designed by Juryj Ostroushko. Ads appeared in both the Minneapolis Star and Minneapolis Tribune, as they were separate papers then, in the university's Minnesota Daily and Connie's Insider, a local bimonthly music magazine.

Ostroushko's poster for the Grateful Dead concert was printed in three colors, which Anthony decided cost too much. Subsequently, he put the artist on a budget of $500 per poster, which meant all of the other posters were limited to one or two colors. Fortunately, Ostroushko was able to use some materials from his job at Headliners, which improved the quality and variety of the posters at no extra cost. Anthony usually gave him short notice of the upcoming bands and dates, forcing him to work on a tight schedule. The amount of individual handwork that Ostroushko performed on each poster often indicated how much time he was given to design it. If he had to work quickly, he did not create any custom lettering or draw an illustration. Rather, he would use existing images and typefaces. If he was given a week or more, he had

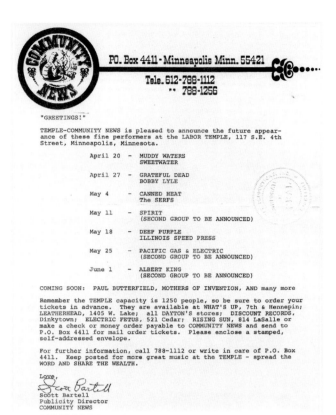

14. *Community News press release for upcoming concerts in 1969. Courtesy of Denny Johnson.*

the luxury of being able to hand-render a picture and design his own lettering.

The artist never received press photographs from the band's record companies or managers, so any imagery that he did not render himself had to be lifted from printed sources. Ostroushko most frequently found photographs of bands in magazines, such as the monthly Teen Set, or used borders, dingbats, and old engravings from stock picture books at work (like *Ornamental Borders, Scrolls, and Cartouches in Historical Decorative Styles*). Printed by offset lithography and usually measuring about 17 x 11 inches, the posters were not printed in consistent quantities, Ostroushko recently guessing that anywhere between 150 and 500 may have been produced for each concert. Once finished, the posters were stapled to telephone poles, by members of Community News (who divided up the Twin Cities), and delivered to shops that would tape them inside their windows. For the February Grateful Dead show even a handbill was produced, by making an electrostatic copy of the poster, rendered in black and white on 8 1/2-x-11-inch paper.

Community News also occasionally issued press releases. An undated one on the group's letterhead listed seven upcoming concerts in April, May, and June

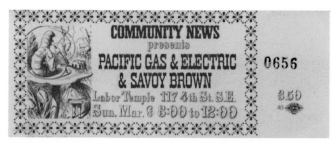

15. Unused ticket.

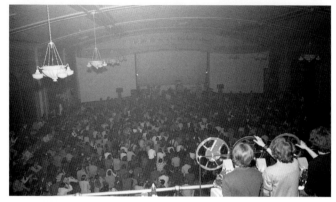

16. Members of Community News working light show projectors from the balcony, 1969. Photograph by Mike Barich.

17. Light show, with Jokers Wild performing, 1969. Courtesy of Denny Johnson.

of 1969, and declared, in capital letters, "Spread the Word and Share the Wealth." It urged individuals to buy tickets in advance or order them by mail, to insure being able to attend (fig. 14).

The Temple tickets were printed separately from the posters, unlike at San Francisco's Avalon Ballroom, which printed them on the same sheets as the posters. Ostroushko established a standard design with the Community News logo and border, inside of which he then added specific information for each show (fig. 15). Tickets for the Grateful Dead show were available at the Leatherhead shop, Dayton's department store, Discount Records, and the Electric Fetus, another record/head shop. They cost $3.50, about the price of an LP record at the time, but increased a little over time. At a certain point, the Minneapolis Fire Marshall imposed a capacity of 1,250 people and required that all the tickets be machine numbered, to avoid overselling. However, some individuals recall seeing collected tickets make their way back to the ticket booth and being resold, in an attempt to increase attendance and revenue.

Light shows were a contributing element to the concerts, just as they had been at Dania Hall. They were projected from the front of the balcony, the equipment taking up a few rows of seats. The remainder of the balcony was open to audience members who preferred the elevated view of the stage, similar to the hall's

window ledges. Once again, Community News provided the lights, but at the Temple everything was "tripled" from Dania Hall, according to Campbell. They stretched three large fabric scrims (each measuring about 20 x 30 feet), one at the back of the stage and the others to each side (fig 16). Visible on the proscenium above the main scrim was a quote from Minnesota governor Floyd B. Olson: "Our Rights Which Labor Has Won, Labor Must Fight to Protect."

With multiple pieces of equipment, it usually took three or four individuals to run the light shows. They utilized 16mm-film projectors, color wheels, and overhead projectors. For the latter, large clock crystals or clear pie pans were used, into which baby oil and colored water were poured. Since the two did not mix, they created fluid, organic shapes that were manipulated in time with the live music (fig. 17). Also projected were stock screens or customized ones that Ostroushko created at work, which when slowly rotated together would create moiré patterns (fig. 18).

18. Moiré transparency used for light shows. Courtesy of Juryj Ostroushko.

19. Audience members in typical dress, 1969. Photograph by Mike Barich.

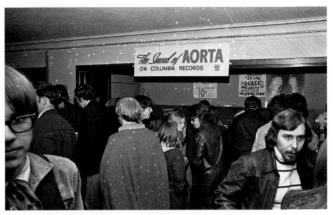

20. Concessions window, 1969. Photograph by Mike Barich.

Like Ostroushko, Jim Donnelly worked at a business where he could surreptitiously produce items used in the Temple's light shows. Such materials included crystalline paint and cut-up 35mm slides. Motion-picture films, borrowed from the public library, added additional movement to the light shows. Among the types projected included European art movies, serials such as Flash Gordon, classics like the original 1933 "King Kong," and cartoons such as "Felix the Cat" and "Betty Boop." These films continued during intermission or other musical breaks, to continuously entertain the audience. In order to better integrate this mixture of visual stimulus and soften the rectangular edges of the images, the light operators sometimes put their moving hands partially in front of the projectors, a technique that Jim Donnelly termed "spooking."

One Minneapolis Tribune reviewer described some of the effects he had encountered at a light show: "weird, brightly colored images keep changing into even stranger forms. Out of the big, purple, pulsating amoeba rides a cowboy from a black-and-white silent movie. An Andy Panda cartoon starts shaking and is, all of sudden, a pink-and-orange geometric design. What looks like big blobs of blood transform themselves into gaudy, green holes, that could be pock marks on a face or craters on the moon."[6] The light shows sometimes had to contend with rather hazy conditions in the ballroom. The same newspaper writer observed that "instead of air, there is a sweet-smelling, smoky smog, caused by heat, sweat, incense and tobacco, and maybe other leaves that burn."[7] When asked about the smoking of pot at the Temple, David Anthony cryptically replied that there was "no more indication of marijuana smoking here than there

would be at any similar event."[8] While getting high and watching the light shows always enhanced one's experience of the live music, Ostroushko observed that if a band was not having a particularly good night musically, you could always count on the drugs and the visual stimulation to round out the evening.

Concert goers at the Temple expressed themselves, in part, through their adventuresome dress, donning beads, scarfs, boots, and other vintage and unconventional garb. They wore clothes that were colorful, mismatched, and often made uniquely for the occasion (fig. 19). One observer, wrote, "See the girl in the long lace dress and no underwear whatsoever. See the clever boy who has made himself a cape by splitting an old pair of pants. See the Susie Cream Cheeses with their long, straight blonde hair, and their big, flowered hats and their funny fur coats they found in grandmother's attic."[9] Another noted that when the concerts started late, as was often the case, the crowd just used the extra time to show off and observe one another's "costumes."

The Labor Temple was an all-ages venue and did not sell liquor. Outside the entrance to the ballroom, refreshments were sold at a concessions window, which featured, among other things, tangerines for 25 cents (fig. 20). On occasion, businesses would set up tables to offer merchandise, such as records, magazines, and posters. For a February 1969 concert by Mother Earth and Spirit, for instance, Discount Records offered LPs by those bands plus others, a bin of import records, and Eye magazine (fig. 21).

The Labor Temple's first season of concerts ran from February to June of 1969. Among the headlining acts

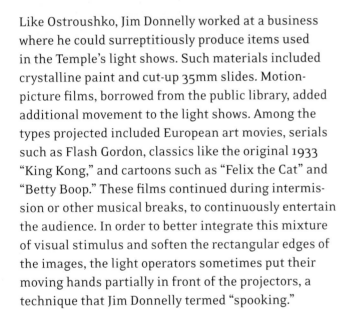

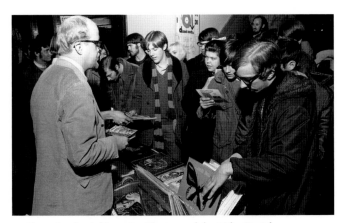

21. *Record Sales table, 1969. Photograph by Mike Barich.*

during the Winter and early Spring were Procol Harum, Jeff Beck Group, Ten Years After, and the Buddy Miles Express. Occasionally two national bands filled the bill, such as on February 9, when Rotary Connection (with Minnie Riperton) and Jethro Tull appeared. Usually, however, local acts opened the shows, with the likes of Jokers Wild and the Litter. Ostroushko designed posters for all of these shows and Community News provided the light shows.

Naturally, parties were thrown after each concert, where musicians and others could comingle in a relaxed setting. Initially, these occurred at the mansion in St. Paul from which Community News had recruited volunteers for the Temple shows. Overlooking downtown and its small airport, the house party usually featured spaghetti, a keg of beer, and a punch bowl spiked with L.S.D. Band members did not always attend, sometimes preferring other places to go, such as the Hell's Angeles own after party, which drew Dead drummer Mickey Hart. The bands' roadies, though, were usually regulars, drawn by the food, drink, and girls. After a short time, however, too many strangers were showing up at the mansion and Community News moved the festivities to the house in which some members lived, conveniently located about five blocks from the Temple. Coincidentally, the St. Paul mansion burned down the night of the Jeff Beck Group concert, on March 23, 1969. Former residents of it moved to a farm west of Minneapolis, in Eden Prairie, which after a time, became the location of the post-concert parties.

During the late Spring another half dozen shows occurred, featuring Muddy Waters, Canned Heat, Deep Purple, and others. Ostroushko continued to

design the posters, but for these shows he turned over his mechanicals to Bradley Armstrong (the younger brother of Community News member Joey Armstrong), who printed them by silkscreen at his high school. The posters in this small group measure about twice the size of the ones printed by offset, and are not as detailed, due to the printing process being less refined. They are also rarer than the others, as they were printed in much smaller quantities (perhaps 100 each). Around this period, a few unauthorized posters for Temple concerts appeared, in addition to those by Ostroushko. None of them are signed, but it is likely that Bradley Armstrong or his friends had something to do with them.

The Winter/Spring 1969 season at the Temple ended with two shows neither of which had posters. The May 26 concert by Pacific Gas & Electric, a blues-rock band from California, was their second time playing there. The band bonded with members of Community News and enjoyed playing in Minneapolis, leading them to return for a third show at the Temple in 1970. At this time, Campbell indicated, "We try to make the groups feel at home here. We want them to have a good time and feel like coming back. If they like it, they play better and everybody's happier. It gets mellow."[10]

The next and last show of the season, however, did not come off as planned. The accomplished blues guitarist Albert King was billed but did not show up on June 1, 1969. The Minneapolis Star titled its review "Performer AWOL from Rock Concert," and began by declaring that the "Labor Temple's first season ended Sunday night not with a bang, but with an uproar."[11] Skin Trade and Jokers Wild, two local bands opened the show, and King reportedly had transportation problems. Public relations manager Scott Bartell had the unenviable job of having to inform the crowd of 1,000 that King would not be performing. The near capacity audience of young, white blues enthusiasts and older, black fans, was not pleased, and they responded with jeers, catcalls, and even obscenities when they were told that they would not get refunds but could use their tickets for any future show.

The situation did not sit well with members of Community News, either. They suspected that David Anthony may not have actually secured a contract with Albert King and did not wish to admit it, due to it being

too late to cancel the show. Anthony, however, insists that he had booked King and remained upset with the musician's agent for some time. Still, as a result of the debacle, Community News broke with Anthony, walking away from his business and the Labor Temple shows. From the beginning, the arrangement between the two parties was strained, as they were so different in temperament and taste. Community News was primarily interested in the music, and Anthony largely the money. Ostroushko recently characterized their loose alliance as one of "mutual disrespect," and it ended on June 1, 1969.

PRESENTED BY THE LABOR TEMPLE
AND DAVID ANTHONY, 1969-1970

Anthony had actually hoped to continue presenting events during the Summer, be it concerts or screening of films such as the Beatles' recent "Yellow Submarine," but the ballroom was too hot, since it had no air conditioning. In fact, even in the Winter, the place got toasty when a large crowd attended, as the many large windows could not be opened, because the music would have disturbed residential neighbors. So, the Labor Temple took the Summer off, although Anthony continued to book and manage local bands.

In the Fall, Anthony once again commenced Sunday night shows at the Temple, now billed as "Presented by the Labor Temple." The first concert of the season featured four local bands: the Marauders, Pepper Fog, Stone Blues, and Thundertree as the headliner. Four more shows occurred in September and October, including one by the MC5. Unfortunately, most of these shows were not accompanied by posters.

Since Community News was no longer affiliated with Anthony, he secured light shows by an outfit called Center of Consciousness, run by Greg Ruud and Richard Tatge. Based on the craft of the San Francisco light show Turquoise One Wing, Ruud and Tatge used various techniques and materials for their presentations. They sandwiched clock faces together, between which were Karo Syrup (a corn oil) and water with food coloring, to create fluid patterns spread by overhead projectors. Center of Consciousness also projected polarized slides and used collodion bandages that would create explosive visuals as they burned up from the heat of the projectors. Moving pictures were also seen, in the form of cartoons such as Walt Disney's "Snow White and the Seven Dwarfs."

Around this time, the authorities finally got whiff of the marijuana use at the Temple. Undercover agents attended concerts at least twice, and made one arrest. At the Dr. John concert on October 5, 1969, Anthony himself was arrested when he ordered narcs out of the building, for either not identifying themselves to him or for not buying tickets to get in. The next week's show, with the Velvet Underground took place as scheduled, but then Anthony temporary suspended operations. He did not wish to invoke any additional police action at shows, which might affect his upcoming trial for obstructing justice. When he did go to trial, however, the presence of a lawyer from the American Civil Liberties Union helped him get off with a not-guilty finding by the judge.

Anthony resumed shows in the New Year, with Pacific, Gas & Electric's third appearance at the Labor Temple on January 18, 1970. The Dutch band Golden Earring opened, along with the local comedian Bobby Kosser, adding a new twist to the shows. Perhaps the most notable change to that evening's presentation, however, was that the bands played twice, at an early (6:30 p.m.) show and a later one (9:30 p.m.). This became a financial necessity for Anthony, as the Minneapolis Fire Marshall had just set 1,250 people as the limit allowed into concerts, which reduced the amount of revenue from a single show. Initially, tickets cost $4.00 for either show, but so many people seemed to prefer the later time that admission to the early shows was reduced to $3.50 to encourage more people to come then.

Two additional changes to the Temple shows occurred with the Pacific, Gas & Electric show. First, the light shows were now handled by a service called Nova, run by Gary Dale and Richard Tatge, the former who had previously helped with lights at Dania Hall. Nova also used water and oil projections, but emphasized projected still slides, both photographic and hand drawn. The second, and more important, change, was that Juryj Ostroushko was back regularly designing posters. Since May of 1969, Anthony had hired him just a few, sporadic times. Now he, once again, began making weekly, artistic contributions. However, instead of turning over his designs to an outside printer, Ostroushko worked directly on press. Jim Parsons, a fellow employee at Headliners, had set up a two-color Heidelberg press in his basement, where the two ran off the posters for the Temple. This gave Ostroushko much more control over the process, allowing them to use a greater variety of papers and inks, such as the times they utilized a split fountain, which produced a rainbow effect of different colored inks blending with each other (fig. 22). On some of these posters they inserted their own logo for the "Pig Puppy Press." Parsons often located stray lots of paper at little cost, so the quantity of posters that were produced resulted from how many mistakes the two made on press and the random quantity of paper secured.

From the Winter to Spring of 1970, Anthony ran another solid string of weekly concerts. The national acts performing at the Labor Temple during this period included Grand Funk Railroad, Allman Brothers, Byrds, Youngbloods, Country Joe and the Fish, and

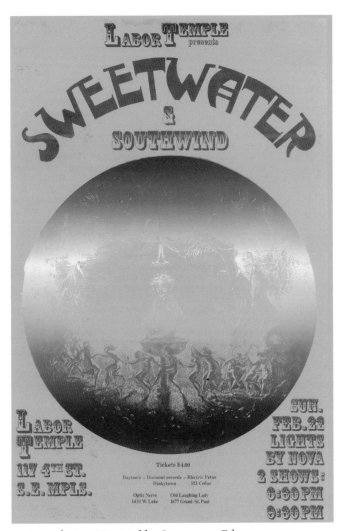

22. Poster by Juryj Ostroushko. Sweetwater, February 22, 1970.

Johnny Winter. During this time Anthony employed for the first time an emcee, one Ken Schaffer. Schaffer, a staple of the Twin Cities coffeehouse scene, always sang about five songs (often covers of Dylan and Donovan), listed a few upcoming shows, and then introduced the evening's musical guests. In mid-April, the university's Minnesota Daily ran an article on the Temple shows.[12] In it, Anthony explained that he spent half his time on the phone (resulting in monthly bills of as much as $700), getting verbal commitments from band managers and only rarely received signed contracts in the mail before the shows. He lamented how some universities were now booking concerts, which was driving up band fees; while last year he could secure a "good feature act" for $2,500 it now cost him more like $4,000. His weekly overhead costs at the Temple were $1,500-1,800. Despite these challenges, Anthony indicated that he was considering buying the Labor Temple building, which was currently on the market. There, he dreamed of establishing a "complete entertainment center," with offices and rehearsal and recording studios. But this did not come to pass, and,

ultimately, he produced only two more shows at the Temple. On April 19, 1970, the Faces (with Rod Stewart) played and a week later the Tony Williams Lifetime, a jazz quartet with former Cream bassist Jack Bruce, appeared.

On May 1, the Minnesota Daily once again turned its attention to Anthony, announcing "Labor Temple Closes." The Tony Williams concert was so poorly attended that it ran $4,500 in the red. Anthony, in fact, declared that he and his backers had lost $12,000 since January and he found the concerts were no longer financial viable, due, in part, to dwindling crowds. Local music fans increasingly were attending other venues, such as the Depot, which opened on April 3, for two nights with Joe Cocker. The Depot shortly thereafter was renamed Uncle Sam's and then became First Avenue. It is now approaching its 50th anniversary as one of the top rock clubs in the country, a lifespan that Temple promoters could only have dreamed about.

Ironically, by this time, Anthony was apparently booking his bands further in advance than previously. He was confident enough to have Ostroushko design posters for two shows scheduled after the Tony Williams Lifetime, which never happened. (See the Concert/Poster section for images of and text on these.) When David Anthony announced that he was stopping presenting regular shows at the Temple, he indicated that he still wanted to try occasional concerts there that he was sure would sell out, such as B. B. King. But, he never did so. Nonetheless, even though Anthony abandoned the Labor Temple in the Spring of 1970, its rock'n'roll days were not yet over.

COSMIC TRIP

MINNEAPOLIS LABOR TEMPLE 1969-70

PRESENTED BY DANA MARVER
AND JOINT PRODUCTIONS, 1970

After the Labor Temple's ballroom lay dormant for the Summer, which was normal, music fans were pleased to read in the September 11, 1970, issue of the Minneapolis Star, that dance concerts would resume there, two days later. The short article indicated that Dick Shapiro's Odyssey Corporation would promote the shows, that they would avoid conflicting dates with the Depot, Guthrie Theater, and Minneapolis Auditorium, and that, as before, the target audience was college students.

While it was true that Shapiro booked the bands, the money and motive behind this resumption of shows was actually that of a 17-year old high-school student named Dana Marver, who had played in bands at Dania Hall and couldn't bear to see the end of music at the Temple. Working with his mother, Gloria, under the name Joint Productions (an obvious marijuana reference), Marver strove to maintain weekly Sunday-night shows of national acts and local openers at the beloved venue (fig. 23). He continued to use the Nova light show, run two shows each night, and use Ken Schaffer as emcee. Jim Kane, the bassist for the Litter, built equipment and ran the sound. But instead of producing posters for his shows, Marver enlisted Tom Brussels, a singer in a local band, to design handbills for them.

Marver's Joint Productions was a family affair, including, in addition to his mother, his brother, Bill, who was put in charge of concessions, and the whole thing was financed with money from his business-man father. Since Dana was underage, Gloria Marver was the one who signed the lease with the Temple, contracts with the bands, and other paperwork. Marver ran advertisements in both the mainstream newspapers and the underground Hundred Flowers. When the Minneapolis Police Department heard that the Marvers were going to revive the Temple, they took the initiative to call Dana to express their interest in working security, since the family was so well respected. No arrests were ever made at shows under Joint Productions and members of a drug counseling organization were always on hand at the concerts. Marver himself usually picked up the national acts at the airport.

Marver commenced his run at the Temple with Savoy Brown, one of his favorite groups. Other headliners during his tenure included Gypsy, Johnny Winter, Sha Na Na, and Poco. Among the local bands opening the shows was the newly formed Jarreau, featuring the young Al Jarreau, during his brief time in the Twin Cities. Previous Temple promoters had twice attempted to book blues guitarist Albert King, but Marver was the only one to

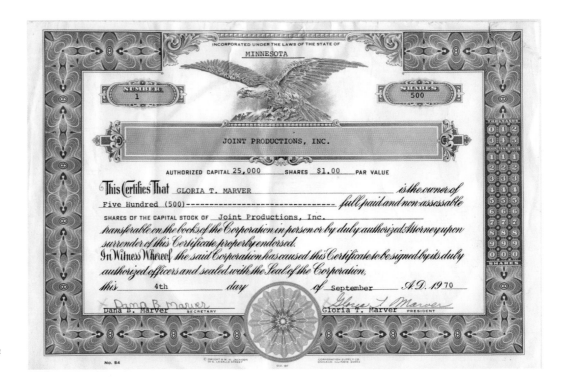

*23. Articles of incorporation
for Joint Productions, 1970.*

succeed, presenting him on November 1, 1970. A week later Marver put on what would be his and the Labor Temple's last show. It featured Alice Cooper and the Amboy Dukes (with guitarist Ted Nugent), who shared top billing by reversing the order in which they played for the second show.

Marver still has the financial records for the eight dance concerts that he put on at the Labor Temple, and they reveal a myriad of expenses for each show. The highest cost was always the musical talent, generally between $2,500 and $3,500 for each headliner. Next came promotion, costing as much a $750 a concert, allocated to newspaper ads, handbills, and radio announcements. It cost Marver only $250 a night to rent the Labor Temple ballroom, but he also had to pay about $200 each for the sound crew and the light show. Lastly, he forked over $100 a concert for his master of ceremonies. On top of these expenses, Marver remembers having to take out riot insurance, probably required by either the Temple or the city, even though the likelihood of peaceful hippies getting violent was miniscule. Bands usually were paid 50% of their fee in advance, and that money was always at risk of not being recouped if the talent didn't show up.

The end of dance concerts at the Labor Temple presaged itself a few months before it happened. After a show in late September, a writer for Hundred Flowers noted, "Going down to the Temple to catch the current

high priest paying mind-fuck music just ain't what it used to be. Surprises have been few and far between and it appears that it's all reached a post-peak stagnation."[13] Labor Temple officials were never comfortable with Dana Marver's young age, and in November informed him that the shows must end by 10:00 p.m., when the late show was not even starting until 10:15.

Previously, Marver had let Dick Shapiro go, believing that he didn't need his help any longer booking bands. It seems that Shapiro sought retribution against Marver, when he drew up a petition about the volume of the rock shows and filed it with the city. Curiously, fewer than twenty people had actually signed the thing and one person lived in a Twin Cities suburb, nowhere near the neighborhood in which the Temple was located. But this document and the continued reticence of Labor Temple officials combined to finally, once and for all, shut down what an early newspaper reviewer had termed the "Sunday Night Social" of music, lights, and pot.[14]

Marver had made a valiant effort at trying to save the Temple for music, but he actually lost money on about half of his shows. He had to cancel the Allman Brothers, who were going to appear on November 15, 1970, and claimed that he was looking for another place to host concerts, but he never found one. At this juncture, young Dana had to admit that it was R.I.P. for the Minneapolis Labor Temple

LEGACY

Three distinct entities had put on shows at the Temple; Community News, David Anthony, and Dana Marver. Forty-two concerts transpired, between February 2, 1969, and November 8, 1970. And in that short amount of time, some big names had stepped onto the Labor Temple's stage two or more times, among them the Grateful Dead, Savoy Brown, Johnny Winter, Golden Earring, Alice Cooper, and Pacific Gas & Electric. Minneapolis became part of the national scene of popular and underground music. And much of it was accompanied and documented by the inspired poster designs of Juryj Ostroushko. The state and the city were greatly enriched by these happenings, creating a heritage that is now a half century old.

NOTES

1. Ed Felien, "Touched by the Hope and Blessed by the Harmony," in Cyn Collins, *West Bank Boogie: Forty Years of Music, Mayhem and Memories*, Minneapolis: Triangle Park Creative, 2006, page 13.

2. *Dania Hall Dances are 'Happenings,'* Minneapolis Star, February 8, 1968.

3. Ed Felien.

4. Tony Glover, *The Business of Pleasure—Temple Style,* Twin Citian, November 1969 (vol. 6), page 38.

5. *Grateful Dead Sock It to 2,000 Rock Lovers,* Minneapolis Tribune, February 3, 1969, page 27.

6. Allan Holbert, *Rock Temple is Where It's At: The Sunday Night Social,* Minneapolis Tribune, March 2, 1969, page E1.

7. Ibid.

8. *Police Trouble: Rock Concerts Will Be Resumed in City,* Minneapolis Star, November 5, 1969, page 4.

9. Allan Holbert, page E3.

10. Charlie Campbell, quoted in Tony Glover, page 38.

11. Marshall Fine, *Performer AWOL from Rock Concert,* Minneapolis Star, June 2, 1969, page 6.

12. Jim Gillespie, *Dave Anthony,* Minnesota Daily, April 17, 1970, page 21.

13. Tom Utne, *Winter,* Hundred Flowers, October 2, 1970 (vol. 1), page 15.

14. Allan Holbert, page E1.

CONCERTS AND POSTERS

This is considered an authoritative compendium of the rock concerts and their accompanying posters at the Minneapolis Labor Temple, which occurred in 1969 and 1970. When posters were not printed or could not be located, the accompanying handbills or newspaper advertisements are reproduced.

The following five serials were thoroughly searched for reviews of the shows: Connie's Insider, Minneapolis Star, Minneapolis Tribune, Minnesota Daily, and Hundred Flowers. The reference "Shefchik" refers to Rick Shefchik, *Everybody's Heard About the Bird: The True Story of 1960s Rock 'n' Roll in Minnesota*, Minneapolis: University of Minnesota Press, 2015, and "Collins" to Cyn Collins, *West Bank Boogie: Forty Years of Mayhem and Memories,* Minneapolis: Triangle Park Creative, 2006. Information was also gleaned from the following two websites: minniepaulmusic.com run by Denny Johnson and Tom Campbell and twincitiesmusichighlights.net created by Jeanne Andersen.

FEBRUARY 2, 1969 [MLT1]
GRATEFUL DEAD
BLACKWOOD APOLOGY
Lights by Community News
Poster by Juryj Ostroushko
Offset lithograph, 17 x 11 inches

After playing two nights at Chicago's Kinetic Playground, the Grateful Dead drove up to Minneapolis to initiate the Labor Temple's run of rock concerts, on Sunday, February 2. At this time, the band was made up of seven members, including the founding five of Jerry Garcia, Bob Weir, Phil Lesh, Ron McKernan ("Pigpen"), and Bill Kreutzmann. Also now part of the group were Mickey Hart, the second drummer, and Tom Constanten, on organ. It was a freezing Winter evening in the Twin Cities, prompting the Minneapolis Star to observe, "Putting heat into the night was the incomparable Grateful Dead with a performance worthy of such rock emporiums as San Francisco's Avalon or the Fillmore." It went on to say, "The Dead play a style of music that could best be described as seemingly about to fall apart at any moment, yet the group is so tight that regardless of how far afield they may wander, they all come together at exactly the right moments." This, of course, refers to the long instrumental parts of most songs, that began and ended with more structured elements of playing (and sometimes singing) in unison.

The absence of chairs and assigned seating, the format used throughout the Temple shows, encouraged interaction between band members and the audience, and the Star reported "superb" rapport. The Dead arrived late, and had a slow start, with minor equipment problems, but then took off musically. This concert is one of only two at the Labor Temple for which recordings are known. The other one happens to be the Dead's second show there, a few months later, and both are available as live streams, online.

They began with "Good Mornin' Little School Girl" (a cover from their first album), with Pigpen on lead vocals and harmonica. After nearly 11 minutes, he ended the song by declaring, "Hey, I don't care if you're only 17 years of age." At this early point, the crowd was apparently not yet grooving with the music, prompting Garcia to complain about the Minnesota weather and characterize the audience as made up of "people who

can't dig it, too weird." Then, he mockingly played the riff to "Louie, Louie." However, once the band settled into "St. Stephen," the second tune, everyone in the hall was on the same wavelength. Next up were "The Eleven" and "Death Don't Have No Mercy," eliciting extended applause by the audience. From their second album, "Anthem of the Sun," they picked "The Other One" and "Cryptical Envelopment," the latter of which they performed in both a short, two-minute version and one that lasted over seven minutes.

To end the concert, Pigpen once again sang lead, for "Turn on Your Lovelight." Running to over 18 minutes, it featured alternating sections of the band at full tilt and playing more sparingly, with just a few instruments. Kreutzmann and Hart presented a short drum solo, Pigpen did some rapping, and the whole group helped end the song with lots of singing and yelping. Throughout the evening Garcia presented inspired and exploratory guitar solos, a signature of the group's sound. The core of this show were the five songs that would end up fully comprising their album "Live/ Dead," released later in the year.

To help enhance the concert's trippy atmosphere, the drug dealer for Community News provided a bag of joints, which were dropped from the stage's catwalk onto the audience, a move that organizer Charlie Campbell termed "pot from heaven." The acid maker and Dead sound man, Owsley Stanley, accompanied the band that night, setting up the massive amount of equipment and, reportedly, taking over the light show. Will Agar, a young musician and budding photographer, was in the audience, taking pictures and taking in the music. He recalls that when he stood up to photograph Garcia and Pigpen (fig. 24), the whole crowd followed suit, staying on their feet for the rest of the show. Agar was so impressed with Garcia's guitar playing that he went out the very next day and bought a matching burgundy-colored Gibson SG guitar, now a classic model of the time.

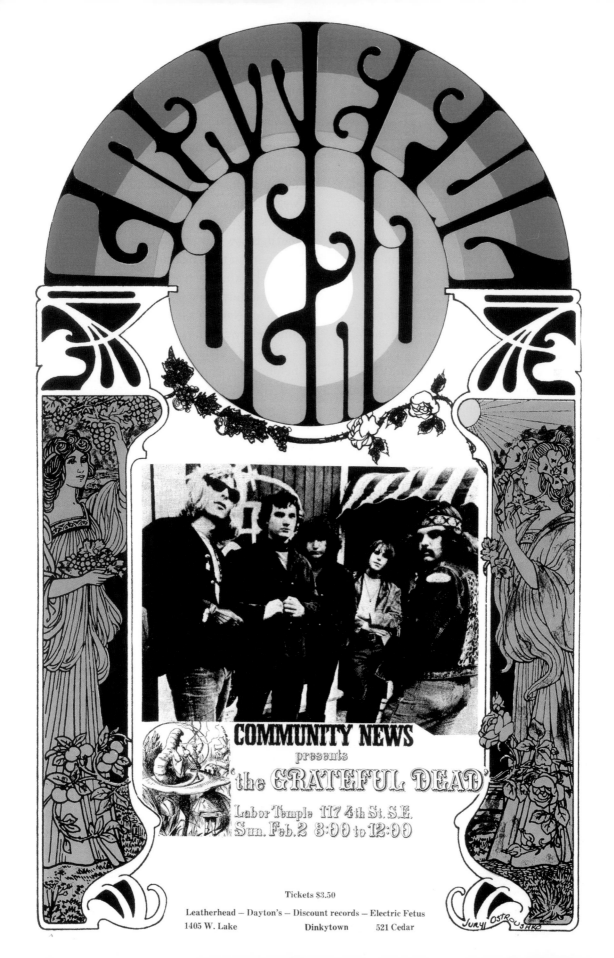

COMMUNITY NEWS
presents
'the GRATEFUL DEAD'
Labor Temple 117 4th St. S.E.
Sun. Feb. 2 8:00 to 12:00

Tickets $3.50

Leatherhead — Dayton's — Discount records — Electric Fetus
1405 W. Lake Dinkytown 521 Cedar

JURYL OSTROUSHKO

Opening for the Grateful Dead was the local act Blackwood Apology, who performed, in its entirety, its new LP "House of Leather." This was a rock opera (preceding the release of the Who's "Tommy" by a few months), written by band member Dale Menten and set in a house of prostitution during the American Civil War. Dennis Libby, Blackwood Apology's lead singer, characterized "House of Leather" as a complex orchestration of rock, jazz, and rhythm and blues, that featured tight vocal harmonies and many changes of tempo. The Minnesota Daily found the show to be a "fine blues set" but the Minneapolis Star termed it only "fair to middling."

This concert was accompanied by both a poster and handbill by Juryj Ostroushko. The flyer was a small, black-and-white version of the larger, color poster, probably made on a copy machine. Community News member John Campbell recalls handing them out in downtown Minneapolis, to people who quickly tossed them into trash cans. One individual, however, excitedly rushed back to Campbell, after reading his, to proclaim that he would definitely be there for the show. It is believed that no subsequent handbills were produced for Labor Temple shows, except for the last eight concerts, when posters were not printed.

Ostroushko's poster for the Dead show contains more elements than most of his designs. Logically, the focal point is the name of the band, presented as an orb-like shape at the top, in multiple colors. Below it is a high contrast, black-and-white photographic image of the group's original five members, captured by Herb Greene on the street in San Francisco's Haight-Ashbury hippie district, where the band lived. Phil Lesh, on the far left, wears sunglasses and leather gloves, while Pigpen, at the far right, sports a headband with a Native American motif. Below this photo is the information about the show, set in type, next to the early Community News logo. Flanking each bottom side of the poster are female figures that Ostroushko appropriated from some Art-Nouveau source. Seen in flowing gowns among flowers and grapes, these women are presented as pink-and-black illustrations that resemble pillars, helping to anchor the design.

REVIEWS
Grateful Dead Sock it to 2,000 Rock Lovers,
Minneapolis Tribune, February 3, 1969, page 27.

Johann Mathiesen, *New Rock Hall Turns on Heat,*
Minneapolis Star, February 3, 1969, page 9.

Tom Boxell, *Temple Brings Dead to Life,*
Minnesota Daily, February 7, 1969, page 10.

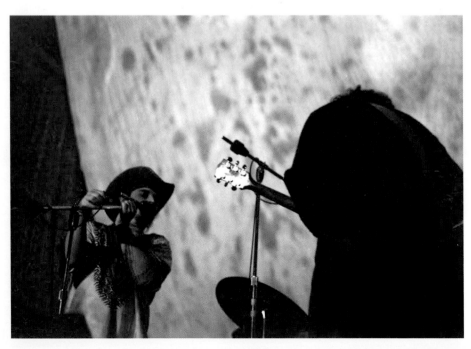

24. Ron McKernan (left) and Jerry Garcia, of the Grateful Dead, performing at the Labor Temple. Photograph by Will Agar.

Minneapolis Tribune Photos by Powell Krueger

EVEN THE VERY YOUNG (LEFT) WERE TURNED ON AT THE ROCK CONCERT SUNDAY NIGHT
The well-dressed and the wildly-dressed were not the only cool cats grooving on the Grateful Dead

Grateful Dead Sock It to 2,000 Rock Lovers

The Labor Temple was packed. The audience, mostly late-high-school and college-age youth, completely filled the chairless main floor, sitting or standing. And all other seats and aisles were taken in the balcony.

As a preliminary to the Grateful Dead, a local group called the Blackwood Apology held forth for an hour or so with the same sort of electric sound.

It came on like just what it was: hundreds of watts of electrified musical power pounding out of great stacks and racks of amplifiers.

And above, lights flashed multicolored, changing images of psychedelia on great wide screens.

Making it happen was the Grateful Dead, a group billed as the leader of underground rock, as the nationally famed but uncompromised original.

The more than 2,000 young people who jammed the Minneapolis Labor Temple to hear them Sunday night took it quite coolly. They liked it, they clapped a lot and some of them danced.

But mainly, they did what you do with this kind of youth art: They experienced it.

After a long delay for setting up their nearly 100 pieces of equipment, the Grateful Dead came on with a sound like the end of a bad trip. It was a horrendously penetrating hum from an amplifier gone mad. But when they got the amplifier squared away, they showed that they can play as well as make noise.

Using some incredibly complex tempos and fine improvisations, they did the mixture of jazz and rock and folk that —along with the lights and,

in some cases, marijuana — has been turning on people around the country for several years.

FEBRUARY 9, 1969 [MLT2]
ROTARY CONNECTION
JETHRO TULL
Lights by Community News
Poster by Juryj Ostroushko
Offset lithograph, 12 7/8 x 9 inches

Rotary Connection was a psychedelic-soul band from Chicago, who released three albums in 1967 and 1968 (fig. 25). It was fronted by the petite Minnie Riperton, with an impressive voice that covered five octaves (and whose biggest solo hit was "Lovin' You" in 1975). Joining her on stage at the Labor Temple was another black singer, Sidney Barnes, also playing congas and tambourine, plus a bassist, organist, drummer, and two guitar players.

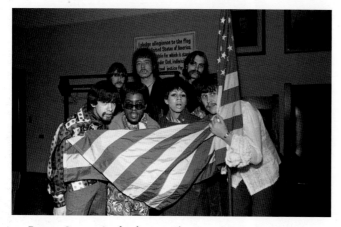

25. *Rotary Connection backstage. Photograph by Mike Barich.*

Audience member Warren Walsh recalls that the crowd numbered only a few hundred people, in great contrast to the Grateful Dead show the week before, and that Rotary Connection was unmemorable. On the other hand, Jethro Tull, the opening band, musically "took our heads off!" (twincitiesmusichighlights.com) And during the break, leader Ian Anderson just stepped off the stage and mingled with the audience, sharing cigarettes. Russell Belk, also in the small crowd, was impressed with the flute-wielding Anderson and the overall tightness of the group. The day after the show, Belk spotted Anderson and bass player Glenn Cornick at the Berman Buckskin store in downtown Minneapolis, leading him to speculate that perhaps this is where Anderson first was inspired to start wearing his signature frilled, knee-high, leather moccasins. This was Jethro Tull's first American tour, and like the Grateful Dead, they came to Minneapolis directly after playing two nights at Chicago's Kinetic Playground.

Coincidentally, the band's first American album, "This Was," was released the very day after the Minneapolis show. No reviews have been found for this show.

Ostroushko, now working with a restricted printing budget, was still able to print this poster in three colors, cleverly using the yellow and red to create orange sections as well. Here he combined fluid, amoeba-like forms with a color wheel of rigidly defined hues. Central to the poster is a topless woman, whose image he lifted from a girlie magazine and then posterized to make her nipple less noticeable. Ostoroushko had to add Jethro Tull's name after he had originally finished designing the poster (due to uncertainty about who was going to be the opening act), and it does appear somewhat crammed into the space next to the woman's head. The original artwork for this poster has survived and it reveals that the show was first planned for a week later, on February 16 (fig. 26). Unlike most other Labor Temple posters, this one did not use any set type, Ostroushko, instead, drawing by hand all of the lettering. Measuring only about 13 x 9 inches, this poster is smaller than most of the others.

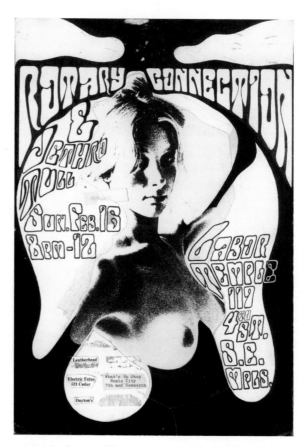

26. *Original artwork by Juryj Ostroushko for Rotary Connection poster.*

COMMUNITY NEWS

presents

ROTARY CONNECTION
& JETHRO TULL

Sun. Feb. 9
8pm-12

LABOR
TEMPLE
117
4TH ST.
S.E.
MPLS.

Tickets $3.50

Leatherhead Discount records
1405 W. Lake Dinkytown

Electric Fetus What's Up Shop
521 Cedar Music City
 7th and Hennepin

Dayton's Jaana
 1704 W. Lake St.

FEBRUARY 16, 1969 [MLT3]

MOTHER EARTH

SPIRIT

Lights by Community News
Poster by Juryj Ostroushko
Offset lithograph, 17 x 11 inches

Fronted by singer Tracy Nelson, Mother Earth had released their debut album, "Living with the Animals," a year before coming from San Francisco to play the Temple. Unfortunately, when they appeared here, Nelson had a bad cold and sang only a few songs, ceding most of the vocal duties to her male counterpart, Powell St. John. The rest of the band consisted of individuals playing saxophone, bass, organ, and drums. Local blues musician Tony Glover attended the show, as he was spotted backstage speaking with Nelson. According to Jim Donnelly, the group stayed on in the Twin Cities for a week after their show, perhaps indulging Nelson's Midwestern roots in Madison, Wisconsin.

While Spirit's name was listed beneath that of Mother Earth on the concert's poster, it is not clear who played first, as both bands were of national stature. And, in fact, the day of the show, a newspaper ad appeared that gave much more attention to Spirit (fig. 27). It mentioned their first hit, "I've Got a Line on You," which had been released just a few months earlier, and indicated that the show would be "Introducing" Mother Earth. Spirit at this time had released two albums, which featured the five original members, among them guitarist Randy California, singer and percussionist Jay Ferguson, and Ed Cassidy, the drummer with the shaved head. For this show, photographer Mike Barich got on stage to shoot some pictures of Spirit from the side (fig. 28). No reviews have been located for this concert.

Apparently drawing on Spirit's name, Ostroushko rendered two enigmatic figures for the poster, showing them strangely intertwined, one with a billowing hood. To the left, a hand rests on a cross-shaped form which suggests a headstone. While Mother Earth's name does top the poster, Spirit's appears larger in size, simply because it took up as much horizontal space and was made up of fewer characters. Filling each band name are moiré patterns similar to those that were sometimes used in the Temple light shows. Here, Ostroushko created a design with fluid lines and forms, but, somewhat incongruously, plopped the image of a concert ticket, with its rigid rectangular shape, over part of the design, the only time a ticket appeared in a Labor Temple poster.

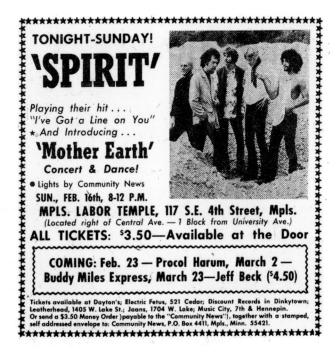

27. *Newspaper advertisement for Spirit/Mother Earth concert.*

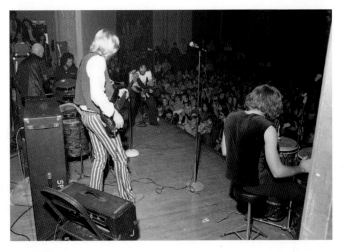

28. *Spirit performing at the Labor Temple. Photograph by Mike Barich.*

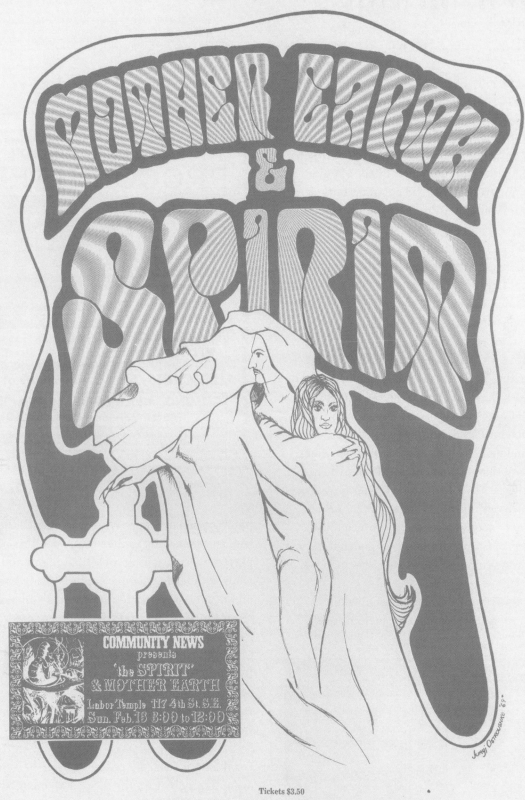

MOTHER EARTH & SPIRIT

COMMUNITY NEWS
presents
'the SPIRIT'
& MOTHER EARTH
Labor Temple 117 4th St. S.E.
Sun. Feb. 16 8:00 to 12:00

Tickets $3.50

What's Up Shop Leatherhead — Dayton's — Discount records — Electric Fetus Jaana
Music City 1405 W. Lake 1704 W. Lake
7th & Hennepin Dinkytown 521 Cedar

FEBRUARY 23, 1969 [MLT4]
PROCOL HARUM
JOKERS WILD
Lights by Community News
Poster by Juryj Ostroushko
Offset lithograph, 17 x 11 inches

When Procol Harum arrived in Minneapolis in early 1969 they had already released two albums, the first of which included their hit "A Whiter Shade of Pale." Unlike most other groups, they did not allow outsiders into the ballroom while they ran their sound check, which took longer than usual because the Labor Temple's piano had to be tuned for member Gary Booker. Once they got started, however, the Minnesota Daily found that they had a strong stage presence during their two "smooth, well-produced sets," featuring Robin Trower on guitar (fig. 30). Generally, they stuck to the shorter tunes off of their records, but got more improvisational with "Kaleidoscope" and "Wish Me Well." Poster artist Juryj Ostroushko remembers that he was helping work the light show when the band broke into "The Devil Came from Kansas." Even though he didn't care much for Procol Harum's sound, the slow, heavy guitar and piano chords of this particular song so entranced him that he momentary forgot to do his part with the lights. "The Devil Came From Kansas" was included on the band's third LP "A Salty Dog," which was released just a month after their Minneapolis appearance. Procol Harum dramatically ended the show that night with "A Whiter Shade of Pale."

The Minneapolis Tribune devoted the equivalent of a full page to a review of this concert, including two

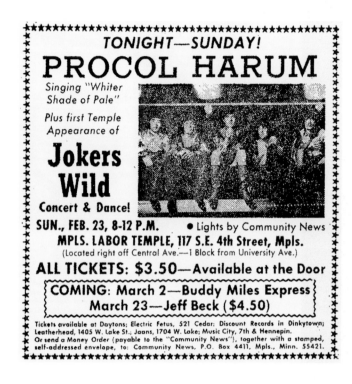

photographs of Jokers Wild, who opened the show (fig. 29). According to the newspaper, this power trio played "wild, crashing rock" that night, and began the show with leader Lonnie Knight's "Lady Luck." Also on the set list were a few new songs—"Shake," with a ten-minute drum solo by Pete Huber, and Donovan's "Season of the Witch," stretched out to 20 minutes of Cream-like instrumentation. Knight later observed that the band "was incredibly psychedelic. You had to have a song 20 minutes long or you weren't anywhere. We would just throw things against the wall and see what would stick." (Shefchik, pages 293-294)

For the Procol Harum poster, Ostroushko chose to prominently feature the head of Medusa. Although none of the band's music references this Greek mythological figure, perhaps he was inspired by the female form on the cover of the group's first album. This woman faces the viewer and has wild hair, while Ostroushko's is seen in profile, with her requisite snake-like locks. He hand lettered "Procol Harum"

29. Jokers Wild (left to right: Lonnie Knight, Pete Huber, Denny Johnson) in the audience, 1969. Photograph by Mike Barich.

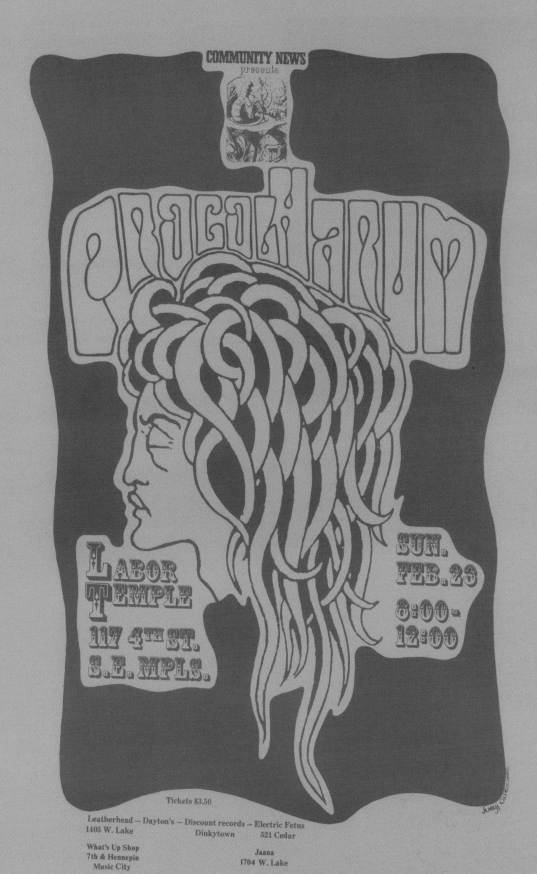

COMMUNITY NEWS
presents

PROCOLHARUM

LABOR TEMPLE
117 4TH ST.
S.E. MPLS.

SUN.
FEB. 23
8:00 -
12:00

Tickets $3.50

Leatherhead — Dayton's — Discount records — Electric Fetus
1405 W. Lake Dinkytown 521 Cedar

What's Up Shop
7th & Hennepin
Music City

Jaana
1704 W. Lake

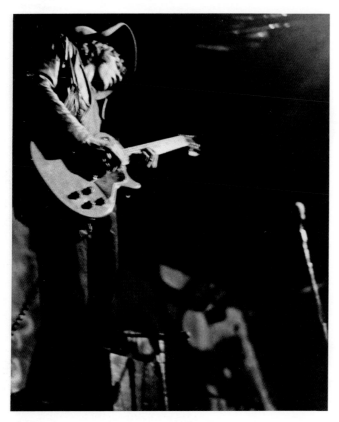

30. *Robin Trower performing at the Labor Temple. Photograph by Jack Sielaff.*

across the top of her head in a sinuous manner that worked well with Medusa's hair. Though printed in only one color, the poster has visual punch, due to the ghastly female figure and the color choice of red on orange. As was sometimes the case, the opening band's name did not appear in the poster.

An alternative, unauthorized, poster exists for the Procol Harum concert (fig. 31). The lower right corner has a partial signature that looks something like Donald Denter.

REVIEWS
Scott Bartell, "*Harum Shines in Concert, Records,* Minnesota Daily, February 28, 1969, page 19.

Allan Holbert, *Rock Temple Is Where It's At: The Sunday Night Social,* Minneapolis Tribune, March 2, 1969, pages E1 & E3.

31. Unauthorized Procol Harum poster. (right)

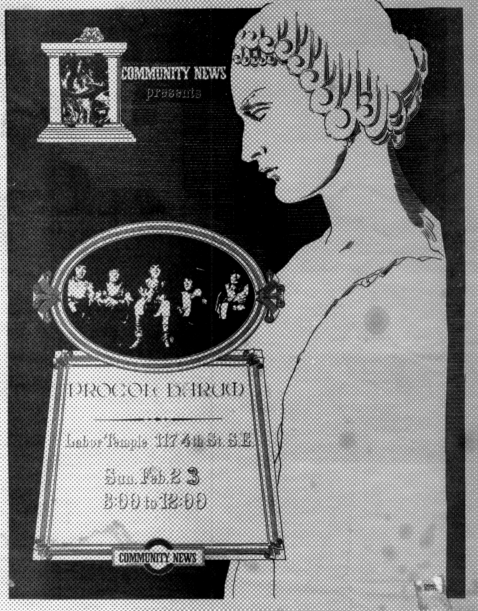

PROCOL HARUM

COMMUNITY NEWS presents

PROCOL HARUM

Labor Temple 117 4th St. S.E.

Sun. Feb. 23

8:00 to 12:00

COMMUNITY NEWS

Tickets $3.50

What's Up Shop Leatherhead — Dayton's — Discount records — Electric Fetus Jaana
Music City 1405 W. Lake Dinkytown 521 Cedar 1704 W. Lake
7th & Hennepin

MARCH 2, 1969 [MLT5]
BUDDY MILES EXPRESS
SOUTH 40
Lights by Community News
Poster by Juryj Ostroushko
Offset lithograph, 17 x 11 inches

Buddy Miles was a founding member of the San Francisco psychedelic big band the Electric Flag, along with guitarist Michael Bloomfield. After they released two albums, Miles went on to form his own group, the Buddy Miles Express in 1968. When they came to Minneapolis, a year later, their first LP, "Expressway to Your Skull," had just been released and the band comprised Miles and eight other members, playing bass, guitar, organ, trumpets, and saxophones. As the leader and singer for this funk-rock band, Buddy Miles and his drum kit of six pieces was up front and center on the stage. Community News member John Campbell recalls dropping D.M.T., a tryptamine derivative, with Miles just before the show and being so stoned that he had to crawl on his hands and knees back to the balcony to help run the light show. Miles, on the other hand, seemingly was not adversely affected, probably due to either his large body mass or his being more accustomed to the drug. Nonetheless, he did occasionally lose his grip on his drums sticks, causing them to fly onto the stage.

The local rhythm-and-blues outfit, South 40, opened for Buddy Miles. Managed by David Anthony, the group included former members of Jokers Wild and the Rave-Ons, and released a record in 1968, with both covers and original songs. Its liner notes read, in part, "Psychologists refer to it as 'normal adolescent self-expression.' Some people call it just 'loud noise.' But to us it's 'What's Happenin'.' Rhythm and Blues is alive!" Just a month after the March 1969 concert with Buddy Miles, South 40 switched drummers and renamed itself Crow, which later that year had a top-20 hit with the song "Evil Woman." No newspaper reviews have been located.

In the poster for this show, Ostroushko used for the first time a typeface he had helped design at Headliners, appropriately named Psychedelic. He utilized it to spell out Buddy Miles Express in capital letters, added a few dingbats, and had it printed in orange. The rest of the poster is more subdued, featuring his wispy illustration of a fairy nymph and more typography, in green.

COMMUNITY NEWS
presents

BUDDY MILES
EXPRESS

LABOR
TEMPLE
1117 4TH ST.
S.E. MPLS.

SUN.
MARCH 2
8:00-
12:00

Tickets $3.50

MARCH 9, 1969 [MLT6]
PACIFIC GAS & ELECTRIC
SAVOY BROWN BLUES BAND
Lights by Community News
Poster by Juryj Ostroushko
Offset lithograph, 17 x 11 inches

This was the first of three times that Pacific Gas & Electric (named after the California utility company) played at the Labor Temple. This blues-rock band had released one LP and were about to come out with another one. The magazine Connie's Insider found their Minneapolis performance to be spirited, with soulful vocals and several "high-flying" guitar solos.

But its reviewer ultimately found the opener, England's Savoy Brown, more moving and accomplished at the blues. Embarking on its first American tour, the band had at its core singer Chris Youlden and guitarist Kim Simmonds. Youlden appeared in a long, heavy coat, with a top hat and cigar, the latter probably adding to his already raspy voice, which sounded like that of black blues singers from the American South. And Simmonds played biting lead guitar solos on his distinctive Gibson Flying V. Connie's Insider proclaimed that together, Pacific Gas & Electric and Savoy Brown constituted the best bill yet at the Labor Temple, each band "emphasizing a deep, gutty approach to the blues."

Reflecting the hippies' appreciation of Native American culture, Ostroushko used an image of the Lakota Indian Chief Sitting Bull for this poster. Photographed in about 1880 by D. F. Barry, the subject confronts the viewer stoically and straight on. The only decoration that Ostroushko used in the design was a ribbon-like shape topping the feathers in Sitting Bull's hair, which frame "Pacific Gas & Electric." It is probably not a coincidence that the brown-skinned Native American is rendered in brown ink and that one of the band's names includes the word "brown."

REVIEW
My Pop, Connie's Insider, March 22-29, 1969 (vol. 2), page 21.

COMMUNITY NEWS
presents

PACIFIC GAS & ELECTRIC

&

SAVOY BROWN
BLUES BAND

Labor Temple
117 4TH ST.
S.E. MPLS.

SUN.
MARCH 9
8:00 –
12:00

Tickets $2.50

junji '69

MARCH 23, 1969 [MLT7]
JEFF BECK GROUP
ZARATHUSTRA
JOHN KOERNER & WILLIE MURPHY
Lights by Community News
Poster by Juryj Ostroushko
Offset lithograph, 17 x 11 inches

Though their names did not appear on the concert poster, two Twin-Cities acts opened for the Jeff Beck Group. First came Willie Murphy and John Koerner, undoubtedly performing songs from their 1967 LP "Running Jumping Standing Still," considered a "psychedelic/folk/blues classic." (Collins, page 113) Next came Zarathustra, a five-piece band who was a two-time winner on "Happening '68,'" a national television show. Their unusual name was probably drawn from "Thus Spoke Zarathustra," the opening musical composition to the 1968 movie "2001: A Space Odyssey."

Six months before appearing in Minneapolis, Jeff Beck (fig. 32) had released his first and highly acclaimed blues-rock album "Truth." Playing on it and at the Labor Temple were vocalist Rod Stewart, bassist Ron Wood, and Nicky Hopkins on keyboards. Local musician Robb Henry recalls that the Labor Temple's upright piano was poorly tuned, adding to the overall "disjointed" sound of the show. Beck and Stewart argued during much of the show, according to another audience member, but he didn't think it affected the quality of the music, only the atmosphere in the hall. Charlie Campbell remembers the sound system sometimes cutting out, prompting Stewart to hurtle his microphone stand through a speaker and storm off stage after their last song "I Ain't Superstitious." He

did not return and the band refused calls for an encore, which upset the crowd.

Band members were such at odds with one another that after this very show, Beck cancelled the remainder of the group's tour, comprising about a dozen concerts that represented a gross loss of $250,000, no small amount in 1969. Beck claimed that he experienced a mild breakdown and that he wanted to start recording the band's second album back in London. This temporary breakup was only one of many by Beck's group, which went on to damage his reputation with both promoters and fans.

Before the show, the young Peter Ostroushko (Juryj's brother) banked one of his most memorable moments at a Temple concert, when he found himself standing between Jeff Beck and Ron Wood sharing a joint. It was after this concert that the communal mansion in St. Paul burned to the ground (probably ignited by a burning candle), although one resident was able to retrieve his stash of LSD for a party elsewhere. The next day, Denny Johnson, bass player for Jokers Wild, drove the band to the airport, where they forgot to completely unload all of their equipment from his van. Upon heading home, Johnson heard three of Beck's guitar cases rattling around in the back of the vehicle and made a hasty retreat to return a Fender Stratocaster and two Gibson Les Pauls. For this show, no reviews have been located.

In the Jeff Beck poster, Ostroushko used the picture of him that appeared on the back cover of the "Truth" album. Presented large scale, this frontal portrait shows his face surrounded with teased hair and two dingbats that suggest the top of his head. Beck is rendered in high contrast and in tonalities that turn his visage into a negative image, delineating only one side of his face. The primarily typography in the poster consists of two blocky fonts, like those used in circus posters, both featuring letters that are divided between the upper and lower halves.

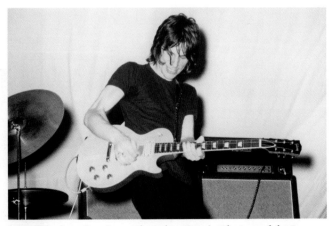

32. Jeff Beck performing at the Labor Temple. Photograph by Jay Smiley.

COMMUNITY NEWS
presents

JEFF BECK

LABOR
TEMPLE
117 4TH ST.
S.E. MPLS.
SUN. MARCH 23
8:00-
12:00

Tickets $4.50

What's Up Shop Leatherhead — Dayton's — Discount records — Electric Fetus Jaxon
7th & Hennepin 1405 W. Lake Dinkytown 521 Cedar 1704 W. Lake
Music City

MARCH 30, 1969 [MLT8]
TEN YEARS AFTER
LITTER

Lights by Community News
Poster by Juryj Ostroushko
Offset lithograph, 17 x 10 7/8 inches

Previous to coming to Minneapolis, the English band Ten Years After had released two albums and the single "I'm Going Home." The latter became their signature song, being one of the highlights at the Woodstock music festival and its accompanying film. Like much of the band's other numbers, it was loud, long, and fast, fueled by the adrenaline of leader Alvin Lee. Ten Years After undoubtedly performed "I'm Going Home" at the Labor Temple, where it was captured on reel-to-reel audio tape. Unfortunately, however, this tape, the recorder, and all of Community News' light-show equipment was stolen overnight from the Temple, so we cannot enjoy the performance today. The organizers rarely did not pack up their gear and take it home directly after the show, and they chose the wrong night to entrust it to the building. Afterwards, Campbell and Donnelly decided not to reinvest in another set of projectors, instead, renting equipment each week for the Sunday shows.

Although the Litter had played Dania Hall twice in late 1968, the group was not booked into the Labor Temple until late March 1969, for this concert with Ten Years After. Formed in 1966, the "Litter" name referred to a brood of puppies, not to trash. They played psychedelic/ garage music and made a modest show of trashing their equipment after each show (inspired by the Who), though they did not actually destroy anything of significance. With two LPs under their belt, they would release their most widely known one later in 1969, titled "Emerge—the Litter." The year before, they made a brief appearance in the film "Medium Cool," about the street fighting at Chicago's National Democratic National Convention, but their music was overdubbed by another band. No reviews have been found for this show.

Ostroushko's poster for the Ten Years After show included a design feature of which he remains proud today—the snake that frames the picture of the band. While many of his other posters also included sinuous borders, here he turned it into an animal, by rendering a tail and head at each end. The former is a simple set of rattles, but the latter is a finely articulated head, with skin, eyes, fangs, and an open mouth, which cleverly frames the logo of Community News. The artist even slipped in a small swastika (barely discernable between the snake's eyes), the ancient religious icon hijacked by the Nazis during World War II. The poster's color scheme is a pleasant pairing of the secondary colors of green and purple.

COMMUNITY NEWS

presents

TEN YEARS AFTER

LABOR TEMPLE
117 4TH ST. S.E. MPLS.

SUN. MARCH 30
8:00 - 12:00

Tickets $3.50

What's Up Shop Leatherhead — Dayton's — Discount records — Electric Fetus
7th & Hennepin 1405 W. Lake Dinkytown 521 Cedar
Music City

APRIL 6, 1969 [MLT9]
AORTA
STILLROVEN
MOJO BUFORD GROUP
KOERNER/MURPHY
Lights by Community News
Poster by Juryj Ostroushko
Offset lithograph, 14 1/16 x 8 inches

In newspaper advertisements, this concert was pro-moted as a "Special Easter Blues Festival." It featured three local acts which did play the blues but, inexplica-bly, a headliner that did not. Dave Koerner and Willie Murphy opened the show, with gutty vocals, mellow lead guitar, and pleasing piano solos, according to Connie's Insider. Next up was the Mojo Buford Group, led by black singer/blues harpist Buford. Born George Buford, he adopted "Mojo" from the song "Got My Mojo Working" by Muddy Waters, who he had played with in Chicago and toured with internationally. When based in the Twin Cities, Buford, strangely, recruited white high-school students for his band. The last local per-former was the Robbinsdale-based Stillroven. Just back from an extensive West-Coast tour, they presented the "smashingest" sounds of the evening, with strong vocals and exciting guitar runs.

Aorta, from Chicago, finished the evening with a set of somewhat thin psychedelic material. Their first album, just released, was part of Columbia record's attempt to promote a "Chicago Sound," when it simultaneously issued LPs by Aorta, Illinois Speed Press, and Chicago. Promotional items for Aorta were placed throughout the Labor Temple—at the concession window and onstage, where a poster reproducing the cover of its album was propped on top of the P. A. speakers. To provide a driving beat to their music, the band situated a large speaker box in the center of the dance floor that constantly emitted a human heart beat. Connie's Insider lamented that Aorta's music did not fit the festival's blues theme, but it did acknowledge that the band was tight and that the drumming was "slashing."

Ostroushko's orange poster for this show used two elaborate images that he borrowed from clip-art books. In the foreground he placed a griffin, a legendary Greek creature with the body, rear legs, and tail of a lion, and the head, wings, and talons of an eagle, being ridden by a figure blowing a large horn. In the back-ground, the artist presented a fancy frame, enclosing the concert's information. Included here for the first time was a new logo for Community News, still using the Alice-in-Wonderland illustration, but now as a more coherent design, presented in a circle. Stillroven was added to the bill after the poster had been printed, so Ostroushko had to hand letter their name on every one, adding a personal touch but taxing his artistic endur-ance by the time he finished them all. Measuring only about 14 x 8 inches, this poster is smaller than most of the others.

REVIEW
My Pop, Connie's Insider, April 12-19, 1969 (vol. 2), page 6.

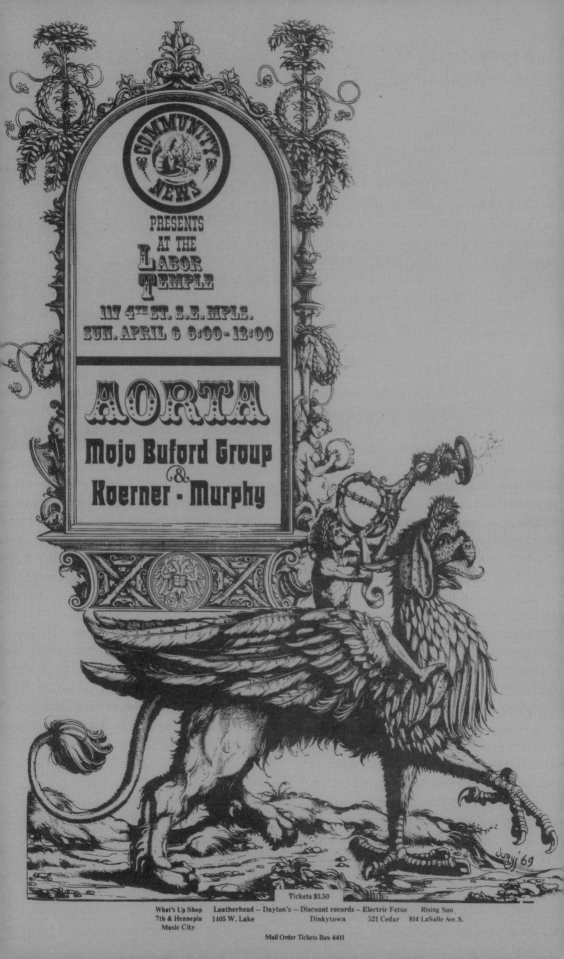

COMMUNITY NEWS

PRESENTS AT THE LABOR TEMPLE

117 4TH ST. S.E. MPLS.
SUN. APRIL 6 8:00 - 12:00

AORTA
Mojo Buford Group
& Koerner - Murphy

Tickets $3.50

What's Up Shop Leatherhead — Dayton's — Discount records — Electric Fetus Rising Sun
7th & Hennepin 1405 W. Lake Dinkytown 521 Cedar 814 LaSalle Ave. S.
Music City

Mail Order Tickets Box 4411

APRIL 20, 1969 [MLT10]

MUDDY WATERS
SWEETWATER
Lights by Community News
Poster by Bradley Armstrong
Silkscreen, 29 x 22 inches

In 1968, Muddy Waters issued "Electric Mud," his fourth album, in which he ditched the traditional blues for a more psychedelic sound. Many fans felt this was a misguided undertaking and Waters, thankfully, had returned to his roots for the tour that brought him to the Labor Temple. Reportedly, Sweetwater was added to the Temple bill, to create a double reference to H_2O.

The Minnesota Daily reported that Waters' first set was disappointing, with the musicians seemingly just going through the motions. The second set, on the other hand, presented the band spirited and engaged. They played "Long-Distance Call," one of Waters' classic songs, with excellent contributions by guitarist Peewee Madison and local harmonica player Mojo Buford. On "Hoochie-Coochie Man" Waters played his guitar with a bottleneck. The last song of the set was "Got My Mojo Working," to which the audience sang along on the chorus. Upon returning for an encore, Waters struck up the very same song, much to the crowd's delight.

The opening band, Sweetwater, hailed from Los Angeles but was influenced by San Francisco's Jefferson Airplane. They had one album under their belt, which included a cover of "Motherless Child," their most well-known tune. Sweetwater was comprised of eight members, fronted by Nancy Nevins on lead vocals and guitar. The amplified cello and electric flute players created unusual feedback with their instruments, and most of the other band members also played accomplished solos. Sweetwater's combination of rock, jazz, classical, and calypso music brought the Temple audience to their feet. Connie's Insider noted that, "For many in the house, the high point of the evening was a half-hour song featuring the electronic keyboard. The man really got it on, reeling off chorus after chorus of soaring, soulful blues." Just four months after playing in Minneapolis, Sweetwater found itself on stage at Woodstock, honored to be the first group to perform at the three-day festival (after solo artist Richie Havens opened the event).

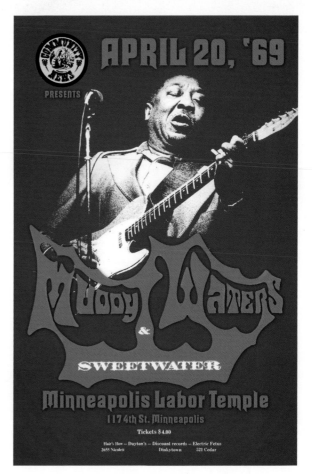

33. *Reissue poster by Juryj Ostroushko. Muddy Waters.*

After the concert at the Labor Temple, a union representative, sporting a clipboard, dutifully collected dues from the bands, backstage. Will Agar, who had played in Mojo Buford's group, gleefully observed this and recalls that Muddy Waters himself paid up, using just pocket change.

Ostroushko designed a poster for this show, the first of about half a dozen that were printed by the silkscreen process, however, an example has not been located. The artist had retained his original lettering and in 2018 he redesigned the poster (fig. 33). On the other hand, an unauthorized poster for this show was designed by Bradley Armstrong (pictured at right), and also printed by silkscreen.

REVIEWS

Marshall Fine, *Muddy Waters' Hard Blues, Sweetwater Rock Group Delight,* Minneapolis Star, April 22, 1969, page B5.

James Gillespie, *At the Labor Temple: Muddy Brings It All Back Home,* Minnesota Daily, April 25, 1969, page 19.

My Pop, Connie's Insider, April 26 – May 3, 1969 (vol. 2), page 12.

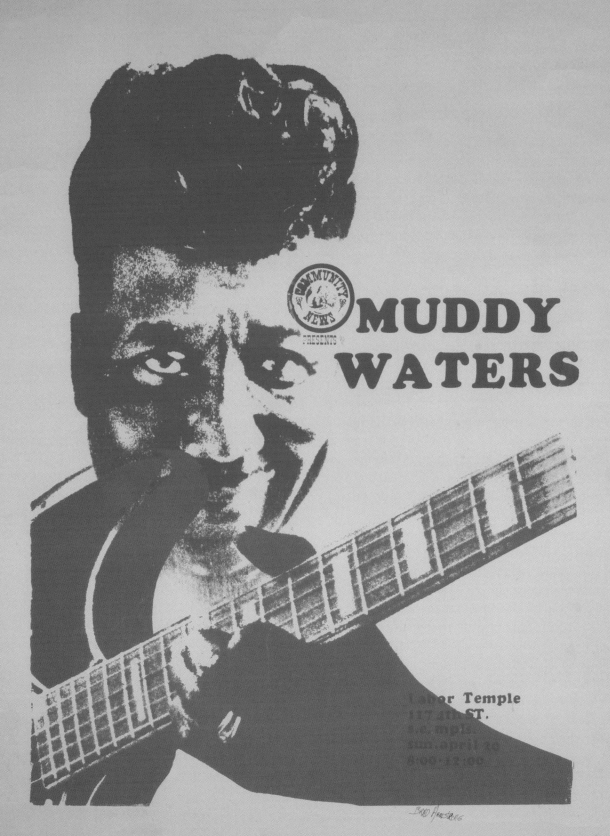

APRIL 27, 1969 [MLT11]

GRATEFUL DEAD
BOBBY LYLE QUINTET
Lights by Community News
Poster by Juryj Ostroushko
Silkscreen, 24 x 18 inches

A few months after opening the Labor Temple's series of dance concerts, the Grateful Dead returned for another performance, in April, 1969. According to promoter David Anthony, they were obliged to play for a reduced fee, due to their having stolen a piece of furniture from the building after their first show. And for this concert, Anthony raised ticket prices from $3.50 to $4.50, where they remained for most of the shows that followed.

The Dead commenced with "Turn on Your Lovelight," the last song of their initial performance, prompting one in the crowd to observe that they had just started where they left off. This 20-minute musical foray once again featured Pigpen singing a gutsy lead, but ended in a non-traditional segue by Jerry Garcia into the next song, "Me and My Uncle." Another short tune followed, namely "Sittin' on Top of the World," from their first LP. Then came "Dark Star," the centerpiece of the concert, running over 25 minutes. This open and moderately-paced song was not only long but also very wide-ranging in the freedom it gave Garcia on guitar.

Next, they played "St. Stephen," which now ended with the "William Tell" section, followed by "The Eleven." Apparently to the delight of the audience, who clapped both at its beginning and end, "Turn on Your Lovelight" was then played for a second time that night. This one was not quite as long as the first go through, but included a short drum solo and additional rapping by Pigpen, in which he told about asking his girlfriend to "ple-e-e-ease" turn her lovelight on him. It concluded with a long section of the band singing the refrain "shine on me." The show's last song was "Mornin' Dew," also from their first album, with Garcia effectively alternating between quiet and loud sections. About half of the songs this evening also were played at the Dead's first show here, and both of these concerts are available streaming, online.

The Grateful Dead were equally well received by the audience this time around. Connie's Insider wrote, "When the Dead really got it on (which is to say, when

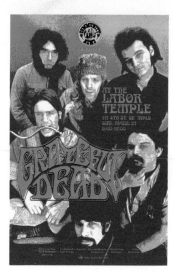

34. Reissue poster by Juryj Ostroushko. Grateful Dead.

Garcia scaled the heights he is capable of reaching), the audience erupted into wild dancing. One brash girl was even moved to leap onto the stage and whomp the conga drums."

The Bobby Lyle Quintet opened for the Dead, something of a mismatch, since they played "supper-club" jazz. Still, Connie's found their combination of keyboard, saxophone, flute, trumpet, and guitar to be "well-rehearsed" and noted that among their selections was the theme for the television series "Mission: Impossible."

Ostroushko's poster for this show sports a very straightforward design, comprising minimal typography and an image of the group (albeit with only six of the seven members who played at the show). As was often the case, he lifted the band portrait from a music magazine, in this case the monthly Teen Set (Jim Marshall was the photographer). However, he flopped the image and rendered it in high contrast, creating a distinctly different impression. For the "Grateful Dead" he utilized his Psychedelic typeface, partially arched and placed nearly dead center. Above this appeared Community News' circular logo, something like a bull's eye, and, unceremoniously, covering the bottom half of Phil Lesh's face. Printed by silkscreen, the paper colors and inks were easily changed, and this poster is known to exist in both yellow and red ink on gray stock and blue and yellow on red. In 2017, Ostroushko redesigned this poster, changing the type face and adding more color (fig. 34).

REVIEWS

Marshall Fine, *The Dead Raises Spirits of Listeners*, Minneapolis Star, April 28, 1969, page 13.

The Dead Returned, Connie's Insider, May 17-24, 1969 (vol. 2), page 34.

PRESENTS

GRATEFUL DEAD

AT THE

LABOR TEMPLE

117 4TH ST. S.E. MPLS.

SUN. APRIL 27 8:00 - 12:00

Tickets $4.50

What's Up Shop Leatherhead – Dayton's – Discount records – Electric Fetus Rising Sun
7th & Hennepin 106 W. Lake Dinkytown 121 Cedar 314 LaSalle Ave S.
Music City

Mail Order Tickets Box 4485

MAY 4, 1969 [MLT12]
CANNED HEAT
SERFS
Lights by Community News
Poster by unknown artist
Silkscreen, size unkown

Canned Head featured Bob "The Bear" Hite, a large, bearded man on vocals, Alan "Blind Owl" Olson on guitar and harmonica, and three other serious blues musicians. After their Minneapolis appearance, Connie's Insider reported that, "The group reaches tremendous emotional heights when belting out its patented, blues-boogie things. They were a gas until guitarist Henry Vestine lost himself in electonicsland during an extended set-closing performance of 'Reef Rid Boogie.'" Vestine, in fact, was so overamped that he blew fuses at the show twice. One boogie number so moved the crowd that it formed a conga line that

snaked around the floor, up into the balcony, and down the main staircase, an experience remembered by most everyone who attended the show. And Canned Heat played so long that the promoter, ultimately, had to pull the plug on the band.

The Serfs, mislabeled as just "Serf," were a jazz-rock group from Lawrence, Kansas, who released an album in 1969. Keyboardist Mike Finnigan was its leader and during their fast and tight set at the Temple tenor saxophonist Freddie Smith provided most of the instrumental solos. The appreciative audience called back the band for two encores.

Ostroushko's poster for this show seems to have been the only one that he designed for the Labor Temple in stark black and white. In it, he prominently featured a human skull, imagery that was usually reserved for the Grateful Dead. It is certainly ghoulish enough, with the band's name inhabiting the skull's hollowed-out eye sockets. No examples of the original poster have been located, and in 2017, Ostroushko reissued the design in a colored version, printed digitally (fig. 35).

An alternative, unauthorized, poster for this show was also printed by silkscreen (at right).

REVIEW
My Pop, Connie's Insider, May 17-24, 1969 (vol. 2), page 32.

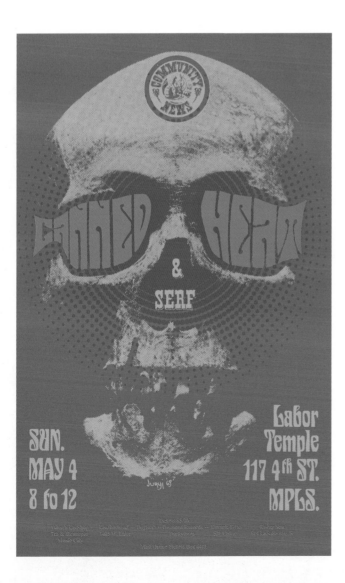

35. Reissue poster by Juryj Osroushko. Canned Heat.

CANNED HEAT

**Labor Temple
117 4th ST.
s.e. mpls.**

**sun. may 4
8:00 - 12:00
Community
News**

MAY 11, 1969 [MLT13]

ILLINOIS SPEED PRESS
SERFS
Lights by Community News
Poster by Juryj Ostroushko
Silkscreen, 24 x 18 inches

In 1965 Paul Cotton and Kal David formed the Rovin'
Kind in Chicago as a rhythm and blues/country outfit.
Three years later they moved to Los Angeles, switched
to blues rock, and renamed themselves the Illinois
Speed Press. They released their first, self-titled, album
in 1968 on Columbia, and by the next Spring were back
in the Upper Midwest performing at venues such as
the Minneapolis Labor Temple and Chicago's Kinetic
Playground. The Serfs, who had opened the bill at the
Temple just a week earlier, played again. No reviews of
this show have been found.

Ostroushko's poster for the Illinois Speed Press promi-
nently features high-contrast, facial profiles of its band
members, lifted from the front and back of the group's
first LP cover. He left open space in the center of the
poster and stacked the heads in a column along the
right-hand side. All facing left, it gives the impression
that they are reading the typographical contents of the
poster. The font he used for the Labor Temple name,
its address, and dates of the show was called Epoque,
an Art-Nouveau-inspired type face that he often also
subsequently utilized.

ILLINOIS SPEED PRESS

& SERFS

Labor Temple
117 4th ST. S.E. MPLS.
SUN. MAY 11 8 PM to 12

Tickets $

What's Up Shop Leatherhead – Dayton's – Discount records – Electric Fetus Rising Sun
7th & Hennepin 1105 W. Lake Dinkytown 521 Cedar 814 LaSalle Ave. S.
Music City

Mail Order Tickets Box 4411

MAY 18, 1969 [MLT14]
DEEP PURPLE
SERFS
Lights by Community News
Design by Juryj Ostroushko
Stat, 10 1/4 x 8 1/2 inches

In 1968, England's Deep Purple was formed by Ritchie Blackmore, John Lord, Nick Simper, and Ian Place, behind lead vocalist Rod Evans. That Fall they released their second album, "The Book of Taliesyn," before their first American tour during October, November, and December. In April and May, 1969, they returned to the United States to play 30 shows, including the Minneapolis Labor Temple. A newspaper ad for this show specifically mentions their then two best known songs—"Hush" and "Kentucky Woman." Both of these were covers, the first written by Joe South and the second by Neil Diamond.

Jim Donnelly, who worked the light show for the Deep Purple concert, remembers that the band had asked Community News to use only purple lights during their set, for obvious, self-serving purposes. But he reasoned that such monochromatic projections would have been visually boring, so the light performers ignored the request and proceeded to present their normal, multi-colored show. Opening the concert that night, for the third week in a row, were the Serfs, who supposedly would be playing songs from their new album "Lady Bird Café." No concert reviews have been located.

Ostroushko produced the above original art for another poster to be silkscreened, but no examples have been found. While the stat gives the date of May 11, the concert actually occurred one week later, on May 18.

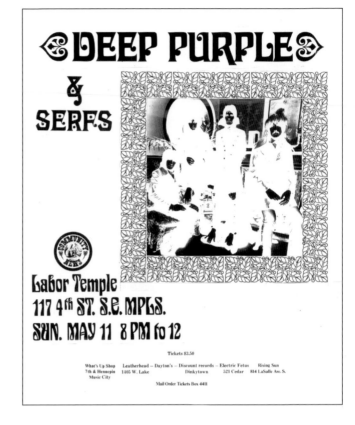

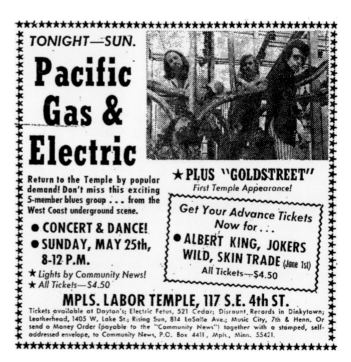

MAY 25, 1969 [MLT15]
PACIFIC GAS & ELECTRIC
GOLDSTREET
Lights by Community News
Newspaper advertisement

This was Pacific Gas & Electric's second time at the Minneapolis Labor Temple. They had played there only two months earlier, with England's Savoy Brown opening, and were starting to endear themselves to the Twin Cities. The newspaper ad declares that they were returning due to popular demand and that they were "from the West Coast underground scene," based in Los Angeles. No reviews have been located.

The opening act, Goldsreet, was a fusion band originally from South Dakota that eventually included all the members of the Minneapolis group Pepper Fog. Ostroushko doesn't recall if he designed a poster for this show and no examples have turned up.

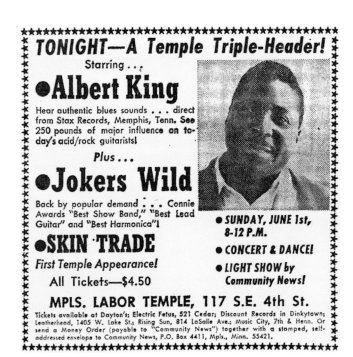

JUNE 1, 1969 [MLT16]
ALBERT KING
JOKERS WILD
SKIN TRADE
Lights by Community News
Newspaper advertisement

Skin Trade, a local band about which nothing is known today, started off the evening. Then came Jokers Wild, the stalwart Minneapolis power trio, headed by Lonnie Knight.

The Minneapolis Star described what happened next: "Scott Bartell, public relations director for Community News, the sponsors of the concert, told the crowd, 'The question that is probably on your lips is on ours also: Where is Albert King?'" It was 10:00 p.m., King had not shown up, and the organizers had no explanation. The crowd did not like hearing that they would not receive refunds but could only get a raincheck for the concert they hoped to reschedule. "The crowd's outrage was understandable. Previous to the announcement, they were forced to endure 45 minutes of the Skin Trade and an hour of the Jokers Wild." Much of the audience was made up of older, black people who had come solely to see Albert King and who apparently had little patience for the loud, noisy music of the young, white bands. The newspaper stated that this, the last concert of the Temple's initial and successful, season, ended "not with a bang, but with an uproar."

In fact, the Temple's compromised concert of Sunday, June 1, 1969, turned into an existential event for the relationship between Community News and promoter David Anthony. Members of the former were skeptical that Anthony had secured a solid agreement with King's management and felt that they took much of the blame for the night's debacle. As a consequence, Charlie Campbell, Jim Donnelly, and the others packed up their lighting equipment for the last time and left the Labor Temple's future rock shows completely in the hands of David Anthony.

Ostroushko was not asked to design a poster for this show, and none by anyone else are known.

REVIEW
Marshall Fine, *Performer AWOL From Rock Concert,* Minneapolis Star, June 2, 1969, page 6.

SEPTEMBER 14, 1969 [MLT17]

THUNDERTREE
STONE BLUES
PEPPER FOG
MARAUDERS
Lights by Center of Consciousness
Poster by Stephen Pfeiffer
Offset lithograph, size unknown

This unsigned poster is believed to be by one Stephen Pfeiffer, who may have designed some other pieces for the Labor Temple, although none have turned up. The poster's central image features a photograph of a woman's face staring at the viewer through barren trees, incongruously paired with two small, running zebras below her chin. Most of the lettering is rendered in an unsatisfying bulbous style, except for the panel at the bottom, which announces the cut-rate admission of only two dollars.

This show represented the beginning of the Fall 1969 season for David Anthony, without the help of Community News and the posters of Juryj Ostroushko. The four bands that played were all from the Twin Cities, beginning with the Marauders, a rhythm and blues outfit who the next year would win the Connie Award for best band, presented by the local music magazine Connie's Insider. Next up was Pepper Fog, made up of the brothers Dale and Bob Strength, on guitar and drums, Gregg Inhofer on keyboards, and Ron Merchant on bass. They adopted their band name after seeing an outdoor Jimi Hendrix performance on

television, where they noticed boxes of "pepper fog" stacked next to the stage, a substance police used for crowd control. The third local act was called Stone Blues, about which nothing is known today, although it is fair to assume that they were a blues band.

The headliner was Thundertree, which had begun in 1967 by John Miesen and Bob Blank as a Top-40 cover band. The next year they began writing original Christian rock music, including a six-song mini rock opera titled "1225," the date of Christmas. After a personnel change, the band adopted the name Thundertree, and in 1970 released an album, including "1225," along with some progressive/psychedelic rock songs. David Anthony represented Thundertree, who often closed their concerts with the Iron Butterfly's "In-A-Gadda-Da-Vida" or an equally long version of "I'm a Man."

For this show, Anthony hired a new light show producer, Center of Consciousness. No reviews of the evening have surfaced.

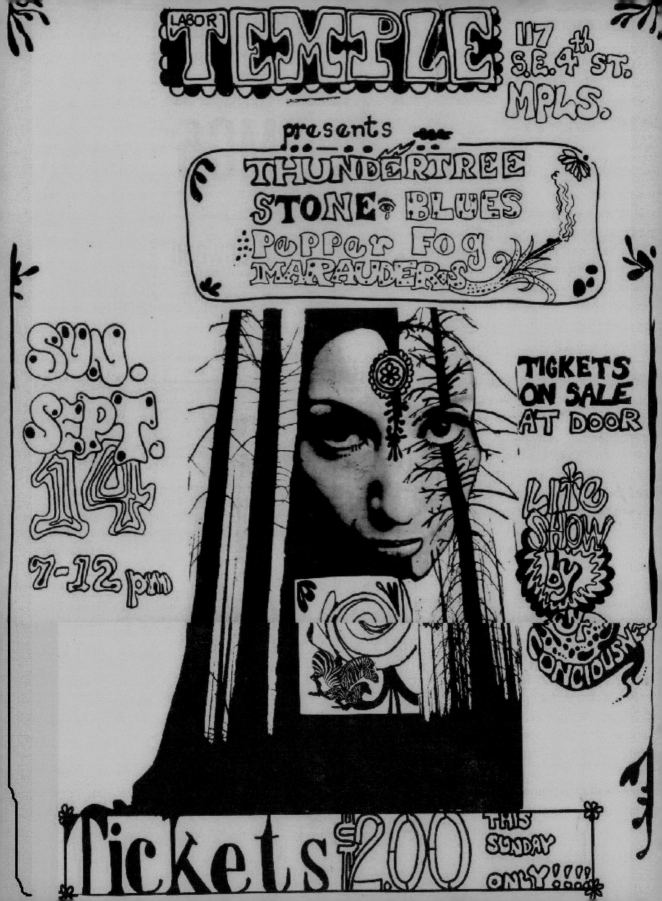

SEPTEMBER 21, 1969 [MLT18]
MC5
COTTONWOOD
Lights by Center of Consciousness
Poster by unknown artist
Offset lithograph, size unknown

When the Motor City Five came to the Labor Temple in the Fall of 1969, they left a strong impression. The Minneapolis Star ran a review titled, "Loud, Louder, Loudest: Rock Group Was So Bad It Was Funny." It stated that "Any semblance of music was lost. You couldn't hear, so much as feel, the bass and drums. Occasionally you could catch the shriek of a wounded guitar but it was squealing so high that dogs in the vicinity of the Temple barked." The university's Minnesota Daily specifically criticized the Star's opinion by countering that the band's music was a "refreshing relief from the ever-increasing sophistication" of recent rock songs. It found that the MC5 fueled the same primitive excitement as such classic performers as Chuck Berry and Elvis Presley, and that they "amplified the image of the golden era of rock because they all looked like juvenile delinquents." But even members of Community News agreed that the band may have turned the volume up too much, with Jim Donnelly recounting that both his ears and his fillings hurt from the loud sound. And Juryj's brother, Peter, decided after the show that he would forever stick to playing only acoustic music.

About six months before their Minneapolis concert, MC5 released their first album, "Kick Out the Jams," a raucous, live recording featuring lead singer Rob Tyner, guitarists Wayne Kramer, Fred "Sonic" Smith, and two others. Among the songs from this record that they performed at the Temple were "Ramblin' Rose" and "Rocket Reducer No. 62 (Rama Lama Fa Fa Fa)." For their last scheduled song, they played the album's title track, which included profanities and Tyner swearing at the audience directly. Apparently unfazed, the crowd allowed itself to get caught up in the band's intense energy, significant volume, and radical political rants

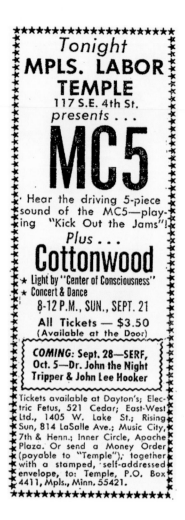

(inspired by manager John Sinclair and the White Panther Party). The show's encore was the classic "Louie, Louie."

Paired with the volume of MC5 was the much softer sound of opener Cottonwood, a folk/country rock group who went on to issue an album in 1971.

REVIEWS
Marshall Fine, *Loud, Louder, Loudest: Rock Group Was So Bad It Was Funny,* Minneapolis Star, September 22, 1969, page 13.

Thomas Utne, *MC5 Plays the Rock That Refreshes,* Minnesota Daily, October 3, 1969, pages 21 and 27.

:·oo: AND :oo·:

cottonwood

LIGHT SHOW BY THE CENTER OF CONSCIOUSNESS

LABOR TEMPLE 117 4th St. S.E.
Sun. SEPT. 21 8:00 to 12:00

Tickets $3.50

ADVANCED TICKETS AVAILABLE AT: EAST WEST LTD...RISING SUN, MUSIC CITY, ELECTRIC PRUNE, AND ALL GRIFFIN'S STORES.

MAIL ORDER TICKETS: TEMPLE, P.O. BOX 4411, MINNEAPOLIS, MINNESOTA 55412

SEPTEMBER 28, 1969 [MLT19]
SERFS
TRIAD
Lights by Center of Consciousness
Newspaper advertisement

The Serfs were mislabeled "Serf" at a previous Labor Temple show, and once again, in promotion for this September 1969 concert. The newspaper ad also, mistakenly, claimed that this would be the third time that they appeared there, when, in fact, it was their fourth and last time. The Charlie Musselwhite Blues Band was supposed to be the headliner but something happened and the Serfs were pushed up to that position.

According to the Minneapolis Star, the Kansas band was not worthy of the spotlight, having "no special charm or charisma." The music magazine Connie's Insider, on the other hand, felt very differently about the show, which it described as a "truly beautiful concert by this well-trained, disciplined, yet always alive and swinging band. Throughout the set we heard the excellent work by the ensemble, the professional and creative arrangements, and the solos by the people on vibraharp, sax and conga drums, which have to be classified as outstanding. Perhaps it should also be added that the group blew its guts out right along, even though it could see how sparse the audience was." Musical taste, even among professional critics, has always varied widely.

Indeed, only about one hundred people showed up for this show, which was opened by the local group Triad. Known as the Olivers before they moved to Minneapolis and rented a house near the Temple, they played some original psychedelic songs and covers by the Yardbirds, Doors, and Beatles. No poster is known for this dance concert.

REVIEWS
Marshall Fine, *Serf Down, 'Pair' Up in Weekend Shows; Audience is Sparse,* Minnesota Star, September 29, 1969, page B2.

My Pop, Connie's Insider, October 18-25, 1969 (vol. 2), pages 13-14.

OCTOBER 5, 1969 [MLT20]
DR. JOHN
JOHN LEE HOOKER
Lights by Center of Consciousness
Newspaper advertisement

"Night Tripper" Dr. John lived up to his reputation for unusual performances, infused with voodoo, spirituality, and witchcraft. He took the stage throwing glitter on the audience and, according to the Minnesota Daily, "wearing floor-length robes, ornate medallions, an eagle with wings spread, perched on his crown, and a scepter with a dead chicken hanging from it. He is weird but he is naturally weird." Behind Dr. John's raspy voice were a trio of female singers, guitars, a piano, and drums.

The Minneapolis Star wrote that the music was "earthy rhythm and blues, but lacked tightness. Songs ended seemingly on a whim, and never in the logical places. They never build to a crescendo but just left you stranded, holding the pieces of an unfinished song." Nonetheless, Dr. John was credited with saving the evening by playing a long 2-1/2-hour set, to fill in for the black blues artist John Lee Hooker, who didn't make the show. There are some indications that Hooker was even supposed to headline this show and that the Serfs may have also played, yet again.

Noteworthy at the Dr. John show were narcotics agents, who unwittingly made themselves noticeable by their short hair and conventional attire. As a result, photographer Mike Barich, who often worked the Temple shows, turned his camera on them repeatedly, in order to alert people to their presence and subsequently publish their images. David Anthony had a run in with the narcs and ended up getting arrested, along with his assistant Greg Gray. Juryj Ostroushko believes he designed a poster for this show, but an example has not been located.

REVIEWS
Marshall Fine, *Star Does Not Show; Dr. John Saves Show,* Minneapolis Star, October 6, 1969, page 14.

Thomas Utne, *Dr. John Trips in the Temple,* Minnesota Daily, October 10, 1969, page 22.

My Pop, Connie's Insider, October 18-25, 1969 (vol. 2), pages 13-14.

OCTOBER 12, 1969 [MLT21]
VELVET UNDERGROUND
PEPPER FOG
Lights by Center of Consciousness
Newspaper advertisement

After their fourth night in a row playing at the club Second Fret in Philadelphia, the Velvet Underground performed the very next evening here at the Labor Temple. An ad in the Minneapolis Tribune promoted their "Sights and Sounds of the Future, Creating a 3-Ring Psychosis, To Assault the Depths of Your Senses." By this time, the band had released three albums, including one about six months before this tour.

The reviewer for the Minneapolis Star began his story by enthusiastically declaring that the "Velvet Underground is outta sight. I got a rush just listening to them." He noted that Lou Reed handled his guitar "like a machine gun" and that Maureen Tucker was the best drummer that he had ever seen, despite the fact that her kit was relegated to a corner of the stage.

David Anthony recalls that the Pop artist Andy Warhol, who was the Velvet Underground's manager, was with the band that night, though no one else has confirmed his presence. Anthony remembers specifically that he showed Warhol around the Labor Temple, since he was considering buying the building at the time, and that the artist even expressed interest in possibly helping with the endeavor, perhaps because it reminded him of his own Factory building back in New York. But nothing came of either idea.

Local band Pepper Fog, playing just a month after their first Temple appearance, performed a show made up completely of original songs. No poster for this concert has been located.

REVIEW
Walter Lide, *'Outta Sight' Describes Rock Group,* Minneapolis Star, October 13, 1969, page 14.

JANUARY 18, 1970 [MLT22]
PACIFIC GAS & ELECTRIC
GOLDEN EARRING
BOBBY KOSSER
Lights by Nova
Poster by Juryj Ostroushko
Offset lithograph, 17 x 11 1/2 inches

This show represented the third and final time that Pacific Gas & Electric performed at the Labor Temple. Only a few months earlier, the band had released its first, self-titled album, on Columbia. Opening the show for the first time was a comedian, one Bobby Kosser, a "hip" New Yorker, according to a newspaper ad for the show. Kosser later appeared on television on both the "Tonight Show" with Johnny Carson and "Late Night with David Letterman."

There was, however, a second musical guest for this show, namely Golden Earring, from the Netherlands. Peter Jesperson, who went on to a lifelong career in the music industry, recalls that the group played a 60-minute rendition of the Byrds' "Eight Miles High." In fact, the band had recently released their second album, with this as the title track, and were promoting the LP on this, their second American tour.

As the poster for this show indicates, the evening now featured two shows, one at 6:30 and another at 9:30, rather than the previous single performance of 8:00 p.m. to midnight. Anthony felt forced into making this change due to the city's fire marshal having imposed a capacity crowd of 1,250 people, which reduced his revenue. Jesperson noted that Golden Earring started late, which meant for a short first set, and, consequently, audience members were allowed to stay for the second show if they so desired. Golden Earring's biggest hit, "Radar Love," did not come out until three years later. Another change unveiled at this show was that the light shows were now run by Gary Dale's Nova. No reviews have been found for this concert.

Ostroushko's design for this poster is one of his most basic. He rendered the central, kneeling nude woman in bulbous shapes with little detail. Her symmetrical form features numerous pairs of body parts—her knees, arms, breasts, and eyes. Most curious are her hands, with fingers and oversize forms that somewhat resemble boxing gloves. Ostroushko admits that he borrowed this figure from a sketch by his brother, Peter, which seems not to have survived. Adding to the poster's simplicity is its limited color scheme, printed in a red (typography) and orange (figure), which are close in both hue and value.

LABOR TEMPLE
presents

PACIFIC GAS & ELECTRIC

GOLDEN EARRING & BOBBY KOSSER

LABOR TEMPLE
1117 4TH ST.
S.E. MPLS.

SUN. JAN. 18
2 SHOWS:
6:30 PM
9:30 PM

LIGHTS
BY NOVA

Tickets $4.00

JANUARY 25, 1970 [MLT23]
GRAND FUNK RAILROAD
FLASH TUESDAY
BOBBY KOSSER
Lights by Nova
Poster by Juryj Ostroushko
Offset lithograph, 16 x 10 7/8 inches

David Anthony told the author that this was the worst show of his entire decades-long career in the music business. It was way too loud and the manager for Grand Funk Railroad was one of the nastiest individuals Anthony ever met, leading him to question his staying in the business. Anthony joked that the Labor Temple ballroom probably echoed with Grand Funk's excessive sound for days after the show.

Grand Funk Railroad originally hailed from Flint, Michigan, where the Grand Trunk Western Railroad ran through town, inspiring the band's name. Guitarist and vocalist Mark Farner fronted the group and often played bare-chested with his long, straight hair flying around. This hard rock trio reportedly sold out their Minneapolis show in just a few hours. The Minnesota Daily noted the concert's high volume, reporting that "everything was so highly amplified as to make it practically unlistenable. Sound and noise for the sake of sound and noise is OK if that is your intent, but when the purpose is to put across a song, then this same sound and noise becomes nothing but an inexcusable intrusion. Just when it appeared they might get down to some real basics, it was gone again, lost amidst a mad vibrating wave of volume which pounded mercilessly at one's head." Grand Funk probably played "I'm Your Captain," a long, well-known song that was released a few months after this concert.

Commencing the evening again was Bobby Kosser, who was described by the same newspaper as an "aborted little creep" and "schlock comedian." The other musical group, Flash Tuesday, was not appreciated either. Calling their sound "obnoxious," the Daily went on

to observe, "Somehow this group seems to be much more concerned with being louder than everybody else, sounding like everybody else, and acting like every other prima donna group anywhere. They're playing to be somebody or to impress somebody, and not for the sake of making good music." Flash Tuesday, in fact, was an altered version of Jokers Wild, one of the Twin Cities' most beloved bands. In late 1969, Pete Huber, Jokers Wild's drummer, stopped playing due to health issues and was replaced by Bill Gent. The group then dropped their old moniker for the new name, Flash Tuesday, using words chosen by each original band member, Lonnie Knight and Denny Johnson. Reportedly, that nasty manager for Grand Funk Railroad was so impressed with Flash Tuesday that he offered them a recording contract, but their manager, David Anthony, advised them against it, citing some instability among band members (the group did break up a few months later).

For this poster, Ostroushko hand lettered Grand Funk's name, making "Railroad" particularly difficult to read. This resulted, in part, from him mixing upper and lower case characters and the word being squashed into an arch shape. The poster also incorrectly gives the date of the concert as January 26, rather than Sunday, January 25. Riffing on the name of the headliner, Ostroushko used an old illustration of a locomotive and train cars ripping across railroad tracks in a mountainous landscape.

REVIEW
David Monasch, *A Grand Funk at the Temple,*
Minnesota Daily, January 30, 1970, page 13.

LABOR TEMPLE

presents

GRAND FUNK RAILROAD

and

FLASH TUESDAY

BOBBY KOSSER

LABOR TEMPLE

117 4TH ST.
S.E. MPLS.

SUN. JAN. 26
2 SHOWS:
6:30 PM
9:30 PM
LIGHTS
BY NOVA

Tickets $4.00

Hair's How — Dayton's — Discount records — Electric Fetus
2655 Nicollett Dinkytown 521 Cedar

FEBRUARY 1, 1970 [MLT24]
ALLMAN BROTHERS
JOHN HAMMOND
Lights by Nova
Poster by Juryj Ostroushko
Digital print, 17 x 11 inches

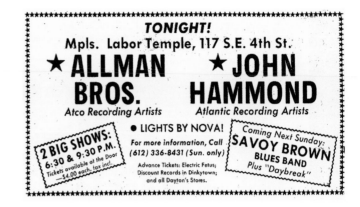

David Anthony liked to tell people that this February 1970 show was the first time that Georgia's Allman Brothers Band had played north of the Mason-Dixon Line, but this is incorrect. The year before they had appeared multiple times in Boston and New York. Nonetheless, it was true that they were little known in the Upper Midwest, having released their first LP just a few months earlier, and that night's meager audience of about 200 people proved the point. Due to this low turnout, those attending the early show were allowed to stay for the second performance. Actor Bruce Bohne, who went to many Temple shows, remembers that the Allman Brothers passed out postcards with an image of them naked in a stream, the picture that graced the inside gate fold of their first album.

The blues musician John Hammond played first, and was sufficiently revered to witness members of the Allman Brothers sitting on the floor with the rest of the audience to take in his set. Hammond performed solid, earthy blues on the harmonica and slide and steel guitars, and among his selections was a crowd-pleasing version of Muddy Waters' "Got My Mojo Working." The Minnesota Daily observed, "He was excellent at continuously alternating the rhythm, doing especially fine work in some intricate guitar riffs. His vocals were hard and straight Chicago style. His harmonica playing was exceptional. Holding, pulling, and bending all his notes, he literally glided along his blues harp."

The Minneapolis Tribune mistakenly called the headliner the Almond Brothers, but appreciated their music, for its variety, arrangements, and the demonstrable abilities of all the band members. It reported that "over a basic and compelling beat the guitars pounded out unison riffs and then burst into big, bold solos." Specific song titles mentioned were "It's Not

My Cross to Bear" and Donovan's "First There is a Mountain," which took the form of a 20-minute jam. At the end of the group's final set, Hammond joined in on a few songs, among them his own new single, the rowdy "Shake for Me."

Uncharacteristically, the Tribune mentioned the concert's light show in its review, declaring that Nova, in just its third appearance, was improving every week, with its throbbing, flashing display of color. David Anthony later claimed to have lost about $3,000 on this show, due to the paltry attendance. One expense he did not occur that night, however, was that for a poster by Ostroushko. For unknown reasons, Anthony did not contact the artist with the concert information, so no poster was designed or printed at the time. Ostroushko designed the poster seen here in 2018.

Also a mystery to Ostroushko was the fact that he didn't attend the concert, even though he was a fan of the band. The Temple's Allman Brothers show seems to have been a night of missed opportunities, with one reviewer even commenting that the audience, as a whole, did not exhibit sufficient appreciation for the group's clear musical abilities.

REVIEWS
Allan Holbert, *Almond* [sic] *Brothers Perform at Temple*, Minneapolis Tribune, February 2, 1970, page 19.

Ron Dachis, *No-Bullshit-Blues at the Temple (Finally)*, Minnesota Daily, February 6, 1970, page 9.

THE LABOR TEMPLE
PRESENTS

The AllmanBrothers and Band

John Hammond

SUNDAY
FEB 1
TWO SHOWS
6:30 & 9:30

LIGHTS BY
NOVA

Tickets $4.00

Hair's How — Dayton's — Discount records — Electric Fetus
2655 Nicolett Dinkytown 521 Cedar

FEBRUARY 8, 1970 [MLT25]
SAVOY BROWN
DAYBREAK
Lights by Nova
Poster by Juryj Ostroushko
Offset lithograph, 17 x 10 11/16 inches

This was London-based Savoy Brown's first show as a headliner at the Labor Temple, having performed about a year earlier as an opening act. Since that time, much of the group's personnel had changed, but it was still anchored by lead vocalist Chris Youlden and guitarist Kim Simmonds. Among the new members was drummer Roger Earl, who had a large kit with two bass drums onto which he emblazoned not "Savoy Brown" but his own first and last names. This surprisingly self-promotional practice may have been common among English groups, as Ginger Baker, of Cream, is known to have done the same thing.

Thanks to an unusually detailed review in the Minnesota Daily, we appear to have a complete set list for a show at the Temple for the one time other than the two Grateful Dead concerts. Savoy Brown opened with "I'm Tired," followed by "Train to Nowhere," with "locomotive-like" drumming by Earl. "Louisiana Blues" was the third song, highlighting three different guitar solos by Simmons, one rough blues, another jazzy, and the last one hard rock. Next up came the 20-minute "Boogie," which got the crowd clapping, dancing, and stomping on the floor. The subsequent three songs were covers—"Whole Lot of Shakin'" by Jerry Lee Lewis, "Little Queenie" by Chuck Berry, and "Purple Haze" by Jimi Hendrix. The eighth and final song of the regular set was "Hernando's Hideaway," featuring Latin-inspired guitar work by Simmonds. The night's encores consisted of Bill Haley's "Shake, Rattle and Roll" and the slow-paced "Honey Bee" (written by Muddy Waters), from Savoy Brown's album "Getting to the Point" and consisting largely of Youlden's soulful voice and Simmond's intricate guitar picking.

The local trio Daybreak opened the concert, and reviews of the show revealed different takes on their music. While the Minnesota Daily characterized the band as "undistinguished," Connie's Insider heard a "fine set" and got the impression that the three musicians enjoyed playing with one another. The latter declared that leader Lynn LaSalle's song "The Keeper" was the highlight of their performance.

36. *Original artwork by Juryj Ostroushko for Savoy Brown poster.*

Ostroushko created a poster for this show that features three key elements. The typography, as was often the case, utilized two different fonts—the blocky, circus-like one and his favored Epoque. The background is an old engraving showing a ravenous forest fire, with swirling smoke rising above a diminutive man leading a horse to safety. Superimposed upon this illustration is Ostroushko's delicate drawing of a lithe, young hippie girl, in a short, flowing dress. Appropriately, she has flowers in her hair, wears an Egyptian amulet around her waist, and is seen flashing the peace sign. There is great contrast between the harsh background image of death and destruction and the foreground one of peace and happiness. Indeed, the female figure seems to float, untethered to the earth, blissfully unaware of the flames behind her. Note that the artist, rather mischievously signed his name under the right hem of the girl's skirt.

For the illustration of the girl, Ostroushko made a few preliminary drawings before finalizing it, a method he also practiced for some other posters. And, here we have one of those variants (fig. 36). The major differences are that the figure is reversed, details such as her hair vary slightly, and the inside of her dress and sleeves are not filled in. The artist recalled that he had originally sketched this girl a few years earlier, to illustrate a magazine article on the hippies.

REVIEWS
My Pop, Connie's Insider, February 7-21, 1970 (vol. 3), page 15.

Will Shapira, *British Blues Group Performs at Temple*, Minneapolis Tribune, February 9, 1970, page 24.

Ron Dachis, *Savoy Brown,* Minnesota Daily, February 13, 1970, page 14.

LABOR TEMPLE

presents

SAVOY BROWN

and

DAYBREAK

SUN. FEB. 8
2 SHOWS:
6:30 PM
9:30 PM
LIGHTS
BY NOVA

LABOR TEMPLE

117 4th ST.
S.E. MPLS.

Tickets $4.00

Hair's How — Dayton's — Discount records — Electric Fetus
2655 Nicolett Dinkytown 521 Cedar

FEBRUARY 15, 1970 [MLT26]
BYRDS
TEEGARDEN and VAN WINKLE
KEN SCHAFFER
Lights by Nova
Poster by Juryj Ostroushko
Offset lithograph, 16 7/8 x 11 inches

For this concert David Anthony added local folk singer Ken Schaffer as an emcee. Next up were Teegarden and Van Winkle, hailing from Tulsa and playing "some powerful gospel rock," inspired, in part, by music from the Southern Baptist Church. Comprised of David Teegarden on a large drum kit and Skip Van Winkle on Hammond organ, the duo had already released two albums of original material, but included in their set covers such as Lou Reed's "Walk on the Wild Side" and Donovan's "Season of the Witch." One reviewer noted the musicians' Okie accents and enjoyed their long tales in between songs.

Headlining that evening were the big-name Byrds, of Los Angeles folk-rock fame. New emcee Schaffer recalls asking the band's guitarist/singer Roger McGuinn how he wanted them to be introduced, to which McGuinn scoffed, "If they don't know us by now, they never will." And to McGuinn's surprise, that's exactly what Schaffer said to the crowd. By the previous year—1969—the Byrds had issued eight LPs and had gone through extensive personnel changes. In fact, McGuinn was the only surviving original member, now joined by Clarence White on guitar, Skip Battin on bass, and drummer Gene Parsons. They had also transformed into a purely country band, having "made their way to Nashville with little difficulty," according to the Minneapolis Tribune. The Minneapolis Star wrote, "This is uncompromisingly a twang combo, an ensemble in which the amplified instruments clang bell-like in a clear, singing manner. The rhythm is consistently accented on the forward leaning half-beat, driving the music onward. The guitar picking is clean and melodic and is notable particularly for its spaces; the ventilation between notes and chords gives the Byrds' playing an unusually fresh, natural, healthy spiritedness." Both shows were well attended and the local press was so enraptured that no less than four reviews appeared of it.

Among the songs the Byrds played were "Nashville West" and "Because They All Look Alike," both unrecorded at the time, "Jesus Is Just Alright," "You Ain't Goin' Nowhere," and several from their most recent, soundtrack album "Easy Rider." The only low point to the concert was the ensemble of short, early songs, like "Mr. Tambourine Man" and "Turn, Turn, Turn," which the band performed seemingly more out of obligation than inspiration. "Eight Miles High," on the other hand, enjoyed extended length and featured an inventive bass solo. The evening's light show by Nova garnered attention from the Minnesota Daily, which overall found it not bright enough, yet still occasionally delivering "terrific effects, like dancing red and green sun beams."

Not surprisingly, Ostroushko utilized a bird theme for the show's poster, rendering feathers, eyes, and beaks, in a somewhat abstract fashion. But he also incorporated a human face, suggesting that the bird imagery represented a fancy hat, perched on top of the hooded head. The amoebic-like outline around the figure is in stark contrast to the sharp, geometric typography. The artist has indicated that the face was that of a Native American man, and one wonders if the little mark underneath his eye was meant to suggest a tear. In fact, Ostroushko based this poster on an already existing design of his (fig. 37). It reveals that for the poster he doubled the bird form, which makes for a busier layout. He also radically altered the color scheme of the original illustration, eliminating the bands of yellow, orange, and red. Instead, the poster was rendered in just two muted colors (pink and blue), creating a more subdued impression. In 2018, Ostroushko issued a redesigned Byrds poster (fig. 38).

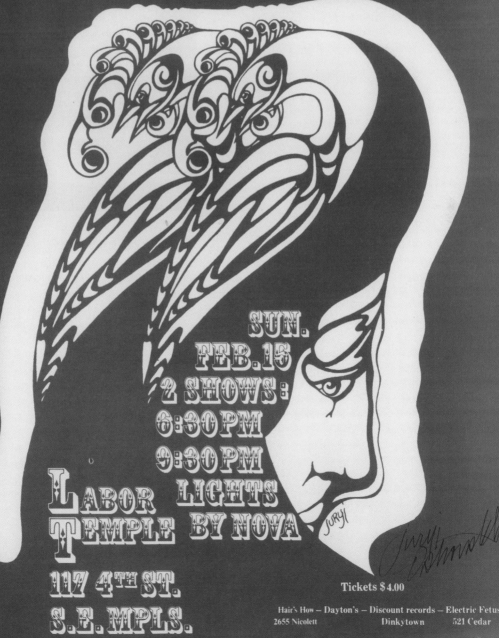

LABOR TEMPLE

presents

THE BYRDS

TEEGARDEN AND VAN WINKLE

SUN.
FEB. 15
2 SHOWS:
6:30 PM
9:30 PM
LIGHTS
BY NOVA

LABOR TEMPLE

117 4TH ST.
S.E. MPLS.

Tickets $4.00

Hair's How – Dayton's – Discount records – Electric Fetus
2655 Nicollett Dinkytown 521 Cedar

REVIEWS
Peter Altman, *The Byrds,* Minneapolis Star, February 16, 1970, page B6.

Will Shapira, *The Byrds Perform at Labor Temple,* Minneapolis Tribune, February 16, 1970, page 23.

Thomas Utne, *Byrds Sing the Smoothest Country in Town,* Minnesota Daily, February 20, 1970, page 23.

My Pop, Connie's Insider, February 28 - March 14, 1970 (vol. 3), page 21.

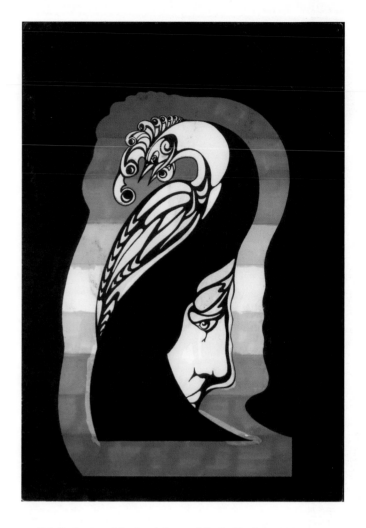

37. Original artwork by Juryj Ostroushko for Byrds poster.

38. Reissue poster by Juryj Ostroushko. Byrds (right).

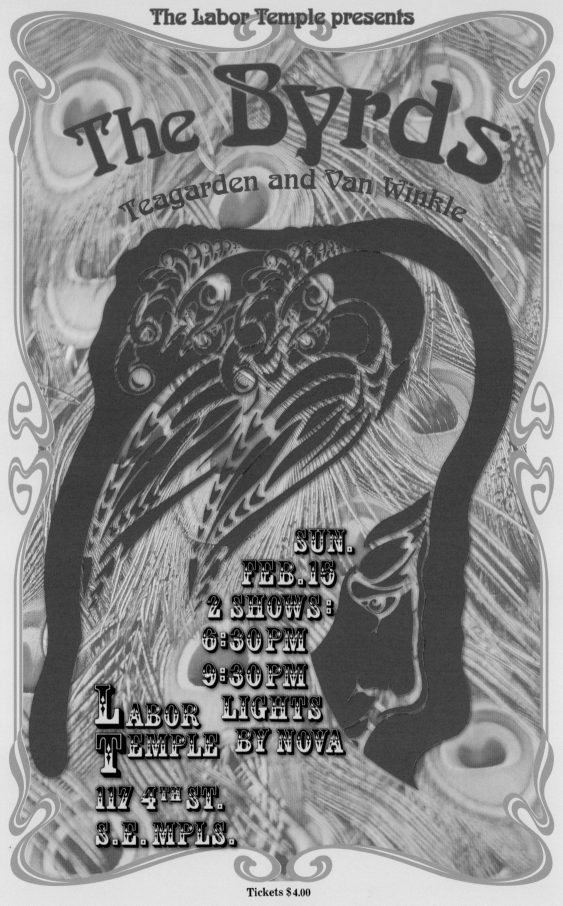

The Labor Temple presents

The Byrds

Teagarden and Van Winkle

SUN.
FEB. 15
2 SHOWS:
6:30PM
9:30PM

LABOR LIGHTS
TEMPLE BY NOVA

117 4TH ST.
S.E. MPLS.

Tickets $4.00

Hair's How — Dayton's — Discount records — Electric Fetus
2655 Nicolett Dinkytown 521 Cedar

FEBRUARY 22, 1970 [MLT27]
SWEETWATER
SOUTHWIND
Lights by Nova
Poster by Juryj Ostroushko
Offset lithograph, 17 x 11 inches

About a year earlier, Sweetwater had opened for Muddy Waters at the Temple, but this time they came back from Los Angeles as headliners. The only problem was that Nancy Nevins, their lead singer, was not along, as she was recovering from an auto accident. Nevins was sorely missed, and the band, wisely, emphasized their instrumental prowess during the show. They opened with a long quotation from a Johann Sebastian Bach suite for unaccompanied cello. Other songs incorporated well-timed shouts and ensemble playing. Most listeners agreed that the long "What's Wrong" was the best song of the evening, featuring solos on piano, flute, cello, and harmonica. At one point flutist Albert Moore expressed the band's affection for Minneapolis, where they felt they had played some of their best shows.

Southwind, a country/hard/blues rock band from Los Angeles, opened the show. In 1968 they had released their debut album and in 1970 they issued their second, which included some songs recorded live at San Francisco's Fillmore Auditorium. At the Labor Temple their "well-balanced" set mixed originals with tunes by others, like Hank Williams and the Rolling Stones ("Honky Tonk Women").

For this Labor Temple poster, Ostroushko used for the first time both metallic ink and a split fountain. The metallic ink glows as if illuminated from behind, while being reflective at the same time. A split fountain is created by putting more than one color of ink on the printing press, which then blends them together in bands as the piece is printed. Thus, with just one pass through the press, a multi-color effect is achieved. Adding to the stunning hues of the poster is the circular shape the artist chose and the illustration in its center—showing fairies dancing around a central, elevated figure that is rendered in reverse tonalities (light on dark). Psychedelic, indeed.

REVIEWS
David Monasch, *Sweetwater,* Minnesota Daily, February 27, 1970, page 12.

My Pop, Connie's Insider, February 28 – March 14, 1970 (vol. 3), pages 18-19.

LABOR TEMPLE

presents

SWEETWATER

& SOUTHWIND

LABOR TEMPLE

117 4TH ST. S.E. MPLS.

Tickets $4.00

Dayton's — Discount records — Electric Fetus
Dinkytown 521 Cedar

Optic Nerve Old Laughing Lady
1431 W. Lake 1677 Grand·St.Paul

SUN. FEB. 22

LIGHTS BY NOVA

2 SHOWS:

6:30 PM

9:30 PM

MARCH 1, 1970 [MLT28]
YOUNGBLOODS
S.R.C.
Lights by Nova
Poster by Juryj Ostroushko
Offset lithograph, 17 x 10 5/8 inches

In 1964 Dino Valenti wrote and recorded the song "Let's Get Together" as a call to love and peace. Many other musicians covered it, but not until the Youngbloods released it three years later (as "Get Together") did it become a hit. Naturally, they played it at their March 1970 Labor Temple show, along with other crowd favorites such as "Sunlight" and "Darkness, Darkness," both of which drew long ovations. Jesse Colin Young, the group's leader and bass player, also performed a solo protest song. The two other members were Joe Bauer on drums and Lowell Levinger ("Banana") on guitar, banjo, and electric piano.

The Youngbloods pleased the crowd with their good stage presence and "easy-going back-porch sound," drawn from the blues, country, and folk music. According to the Minnesota Daily, "Their cordial nature exudes homespun warmth and a complete absence of pretense and ego. The combination of their musical virtuosity, their candid humor, and the always pervading air of kindness and gentleness make the Youngbloods not just effective social commentators, but lovable enough, when it's all working, to pied-pipe their way anywhere." They so rejected stardom that they had the spotlight directed away from them, onto the ceiling, although some in the crowd then found it a little difficult to observe the musicians on stage. Nonetheless, the band garnered two encores.

The group S.R.C. commenced the evening and were anything but mellow, like the headliners. Some found their music too loud and distracting from the decent instrumental parts in their classic rock songs. They took their name from the initials of the lead singer, Scott Richard Chase, who dressed in somewhat exaggerated hippie garb. With three records on Capital, they were by this time a staple at venues in their hometown of Detroit.

Inexplicably, Ostroushko chose for this poster an old illustration of figures on a tilting clipper ship, with a drinking pirate prominently placed in the center. Such a ruckus scene contrasted greatly with the gentle nature of the music of the Youngbloods, but maybe he was riffing on the "blood" part of their name. He selected a bulbous typeface for the names of the two bands, adding an outline to "Youngbloods," and used his preferred Epoque font for the rest of the info. And like other examples in which he used such engravings, the imagery bleeds off the edges of the poster.

REVIEWS
Dodd Lamberton, *Youngbloods' Music, Humor, Presence Please Audience,* Minneapolis Star, March 2, 1970, page B3.

Thomas Utne, *Youngbloods,* Minnesota Daily, March 6, 1970, pages 19 and 23.

Labor Temple

presents

YOUNGBLOODS

and

S.R.C.

Labor
Temple
117 4th St.
S.E. Mpls.
Lights
by Nova

Sun.
March 1
2 shows:
6:30 pm
9:30 pm

Tickets $4.00

Dayton's — Discount records — Electric Fetus
Dinkytown 521 Cedar

Optic Nerve Old Laughing Lady
1431 W. Lake 1677 Grand·St. Paul

39. *Country Joe McDonald performing at the Labor Temple. Photograph by Mike Barich.*

MARCH 8, 1970 [MLT29]
COUNTRY JOE and the FISH
RUGBYS
Lights by Nova
Poster by Juryj Ostroushko
Offset lithograph, 16 7/8 x 10 7/8 inches

Country Joe & the Fish hailed from Berkeley and were initially known for their politically inspired songs, some about the Vietnam War. By the time they traveled to Minneapolis, only one original member besides Joe McDonald remained—lead guitarist Berry Melton. They did perform "Not So Sweet Martha Lorraine" from their first album (1967), but didn't even rouse the "Fish Cheer," during which they would spell out "F-I-S-H" or another word beginning with the letter "F." According to the Minnesota Star, Melton produced some "exceptional" guitar work but it was not enough to rescue the show of "boring" music and "hackneyed blues." The band was able to bring the crowd to their feet for Bill Haley's fast-paced "Rockin' Around the World," yet audience members refused to sing along to the cover of Woody Guthrie's "Roll on Columbia."

Peter Jesperson remembers McDonald (fig. 39) shouting "Let there be light" at the beginning of the show, since the house lights were down, prompting many to light up matches. As a result, those in the balcony were almost overcome by the collective sulphur fumes. Local musician Tony Glover attended the show and was photographed backstage conversing with Country Joe. The opening act this evening was the Rugbys, from Louisville. According to the one newspaper review they performed solid rock music, but possessed little showmanship, and they "died in a blaze of mediocrity."

Ostroushko's hand-lettered "Country Joe and the Fish" for this poster is perhaps his most accomplished such example in the Temple posters. Heavily influenced by the San Francisco designer Rick Griffin, these sharp, three-dimensional letters wiggle with energy and gently nudge one another. Fortunately, the original art has survived (fig. 40). Note that Ostroushko minimized "Joe" in the design, making it read, at a glance, as "Country Fish." The background photograph of the band (which pictures the original five members) was likely lifted from a music magazine, as was Ostroushko's normal practice, and it was also used as a press print by Vanguard Records (fig. 41). Joel Brodsky made this

picture and photographed the band extensively, including for the cover of their second and most important album, "I-Feel-Like-I'm-Fixin'-To-Die" (1967).

REVIEW
Marshall Fine, *Fish Boring—Not Like Before*, Minneapolis Star, March 9, 1970, page B2.

40. *Original artwork by Juryj Ostroushko for Country Joe and the Fish poster.*

41. *Country Joe and the Fish. Photograph by Joel Brodsky.*

MARCH 15, 1970 [MLT30]
GOLDEN EARRING
FIFTH AVENUE BAND
Lights by Nova
Poster by Juryj Ostroushko
Offset lithograph, 17 x 10 7/8 inches

The Dutch band Golden Earring returned to the Labor Temple in March of 1970, now as headliners. In between their two shows here, Golden Earring had performed in Toronto, Seattle, San Francisco, Los Angeles, and San Diego. Their longest stint was at LA's Whiskey A Go Go, where they put on ten shows. On March 18, three days after the Temple show they flew back to the Netherlands, and the concert here may have been their last one on this tour.

The Fifth Avenue Band, based in New York's Greenwich Village, were influenced by the Rascals and the Lovin' Spoonful, two other East Coast groups. The year before the show here, they released on Reprise their self-titled, first LP. This concert has not shown up in any reviews.

Probably reflecting a short amount of time to work on the poster for this show, Ostroushko here used an existing image and a regular typeface, rather than performing any handwork. The old engraving he selected pictured a woman shining a light from a stone balcony down onto a group of children, huddled together in probably both fear and the cold. This was an illustration by Gustave Doré for a 1860s book of fairy tales by Charles Perrault, which carried the caption, "Who Are You, You Queer Little Crew?" Ostroushko cleverly used a split fountain this time to emphasize the bright illumination of the beam, which is paper white at its source. Perhaps Ostroushko was here also giving a nod to the light shows at the Labor Temple, this concert's being provided by Nova.

Labor Temple
presents

Golden Earring
and
5th Avenue Band

Labor
Temple
117 4th St.
S.E. Mpls.
Lights
by Nova
Sun.
March 15
2 shows:
6:30 pm
9:30 pm

Tickets $4.00

MARCH 22, 1970 [MLT31]

JOHNNY WINTER
THUNDERTREE
Lights by Nova
Poster by Juryj Ostroushko
Offset lithograph, 17 1/8 x 10 7/8 inches

Enthusiasm for this show ran high, as Johnny Winter was a widely heralded blues guitarist. According to promoter David Anthony, 1,000 people were turned away from the second show, due to its being sold out. When Winter took the stage the crowd roared "Welcome Back," even though this was his first time playing the Temple. They were referring to his show just two days earlier at a music festival at the Metropolitan Sports Center. At the Labor Temple, Winter stacked into a pyramid six blonde Twin Reverb Fender amplifiers and exhibited fast and clean guitar technique on songs such as "Johnny B. Goode." Most exhilarating were the shoulder-to-shoulder extended blues and jazz duets that he performed with his brother, Edgar, on alto saxophone. On "Tobacco Road" Winter effectively played the harmonica, both inhaling and exhaling, and "Rollin' and Tumblin'" was the set's encore number.

The local group Thundertree opened the show, and according to a newspaper ad, they would be "doing heavy material from their brand-new Roulette album." Billy Hallquist, the group's guitarist, remembers that they had to cut short their first set because Winter's equipment arrived late and he wanted to use his own P.A. system. But, "During the second show we got to play our entire set, including our 30-minute version of 'I'm a Man.' During my extended solo, I noticed that Johnny was standing on the side of the stage groovin' along with me. I must admit I felt a little uneasy watching him watch me." (twincitiesmusichighlights.com). Connie's Insider recounted that the band performed inventive, original songs, plus Tennessee Ernie Ford's "16 Tons."

Ostroushko's poster for the Winter show utilizes a gruesome Old-World scene of a beheading. The victim seems resigned to his fate, judging from his limp wrist, as the executioner raises a substantial cleaver emblazoned with the skull and crossbones on its blade. In the background the turret of a church suggests that this action may have been religiously sanctioned, but the faces of the crowd below indicate suspense and horror. Like in the previous week's poster, Ostroushko used horizontal bands of different colored inks (blue, green and yellow), this time to focus attention on the unfortunate man in the center of the image.

REVIEWS

Will Shapira, *Winter Performs at Labor Temple,* Minneapolis Tribune, March 23, 1970, page 25.

My Pop, Connie's Insider, April 11-18, 1970 (vol. 3), page 18.

MARCH 29, 1970 [MLT32]
FEVER TREE
MOJO BUFORD BAND
Lights by Nova
Poster by Juryj Ostroushko
Offset lithograph, 17 9/16 x 11 1/4 inches

When the five members of the Los Angeles band Fever Tree took the stage at the Minneapolis Labor Temple, they were led by the strong vocals of Dennis Keller and the experimental keyboard textures of Rob Landes. By this time they had released three albums, including their self-titled debut record of 1968, featuring the Baroque pop hit "San Francisco Girls (Return of the Native)," which they undoubtedly played that night.

Mojo Buford and his band opened the evening with his characteristic Chicago blues. Previously, he had played the Labor Temple for the Easter Blues Festival in April 1969 and had sat in a few weeks later with Muddy Waters, his mentor. This show has not been found to have been reviewed in the local press.

This time, Ostroushko used both a split fountain and a straightforward run through the press. He took the circular image, picturing a young girl and a bearded man, from a large book of old illustrations made for designers and printers. The child, who resembles Alice in Wonderland, peers up at the seated figure, who is wearing a turban, smoking a long-stemmed pipe, and is surrounded by Oriental rugs, in an exotic setting. Framing the image is all the normal required data for the dance concert, in two related Art-Nouveau-inspired fonts, printed in blue. Appearing for the first time here is the "Pig Puppy Press" logo at the bottom right, a name that Ostroushko and his printing partner had recently adopted.

Labor Temple

presents

Fever Tree
and
Mojo Buford Band

117 4th St. S.E. Mpls.

Lights by Nova

Sun. March 29

2 shows:
6:30 pm
9:30 pm

Tickets $4.00

Dayton's — Discount records — Electric Fetus
Dinkytown 521 Cedar

Optic Nerve Old Laughing Lady
1431 W. Lake 1677 Grand · St. Paul

APRIL 19, 1970 [MLT33]
SMALL FACES with ROD STEWART
ALICE COOPER
Lights by Nova
Poster by Juryj Ostroushko
Offset lithograph, 17 1/16 x 10 15/16 inches

Late in 1969 the Small Faces broke up, only to reform as simply the Faces in January 1970, with the addition of Rod Stewart and Ron Wood, both previously in the Jeff Beck Group. By three months later they had issued their "First Step" album and were touring the United States. As is evident from the poster for their Labor Temple show, they were still sometimes mistakenly referred to by their old name, and the first thing that Stewart did after the band was introduced here as the Small Faces was to set the record straight by saying, "We're just the Faces now."

Unfortunately, their first set was marred by a "disastrously" poor balance of sound, with the bass too loud and Stewart's vocals and all the other instruments nearly inaudible. Fortunately, this situation was rectified for their second go around, which the Minnesota Daily appreciated. "Rod Stewart was in great form. His peculiar wooly voice scraped and burned the lyrics of each song into the listener's ears. In a line-trading duet with bassist Ronnie Lane, he dropped to his knees and let the power of his voice reach the audience half-unaided by his mike." Much of the material they played was so new that many audience members did not recognize it. This included selections from Stewart's first solo album of 1969 and many from "First Step," which was issued only the month before the Temple concert. Among those from the latter were "Devotion," "Flying," the Dylan cover "Wicked Messenger," and the slow instrumental "Pineapple and the Monkey," which the newspaper called an "elephantine cakewalk" (whatever that meant). They ended with the much requested "Around the Plynth," but returned with three encores, including "I Feel So Good" and "Three Button Hand Me Down." Denny Johnson, of the local band Jokers Wild, recalls that the Faces used some of their equipment for that evening's shows, something that happened at a few other Temple engagements.

The zany Alice Cooper (fig. 42) opened the Faces show and were not much appreciated by the Minneapolis audience. The Daily quipped, "This group is Frank Zappa's unhappiest discover. Their music is all blaring

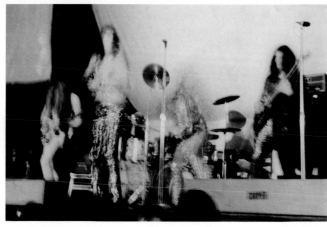

42. *Alice Cooper performing at the Labor Temple. Photograph by Jack Sielaff.*

chords and unremarkable singing with banal lyrics to boot." It noted their makeup, whips and other props, and their "aluminum-foil shiny" clothing. The band concluded with an energetic "science fiction number," during which band members blew smoke and feathers around the hall, jumped from amps, crawled on the floor, verbally insulted the audience, and charged into the crowd with axes. After it was all over, the audience was so stunned that it didn't even applause. According to local musician Dale Strength who was backstage afterwards, leader Alice Cooper responded to this silence by saying, "Yeah, isn't that great?" The negative opinion of Hundred Flowers, a new Twin Cities underground tabloid, was "Fuck you, Alice."

The poster for this show features an old engraving of a well-dressed gentleman sitting in a jail cell. The place was not all that shabby though, as the prisoner was provided with newspapers, a table lamp, a bottle, and a stemmed drinking glass. While the man sits defiantly with his arms crossed, escape from the place looks unlikely. The pattern of vertical and horizontal bars dominates the foreground and completely fills the frame of the image. Ostroushko printed this poster in a single, vibrant purple color (perhaps suggesting that the bottle was filled with red wine), which helped to emphasize the lines in the original illustration.

REVIEWS
Ray Olson, *Small Faces,* Minnesota Daily, April 24, 1970, page 13.

Recent Concerts, Hundred Flowers, April 24, 1970 (vol. 1), page 6.

My Pop, Connie's Insider, May 2-9, 1970 (vol. 3), pages 18-19.

Labor Temple

presents

SMALL FACES
with
Rod Stewart
and
ALICE COOPER

117 4th St.
S.E. Mpls.
Sun.
April 19

Lights
by Nova
2 shows:
6:30 pm
9:30 pm

Tickets

6:30 Show - 3.50
9:30 Show - 4.00

Dayton's — Discount records — Electric Fetus
Dinkytown 521 Cedar

Old Laughing Lady Optic Nerve
1677 Grand St Paul 1431 W. Lake

APRIL 26, 1970 [MLT34]

TONY WILLIAMS LIFETIME with JACK BRUCE
ILLINOIS SPEED PRESS
Lights by Nova
Poster by Juryj Ostroushko
Offset lithograph, 17 9/16 x 11 1/4 inches

The Tony Williams Lifetime formed as a power trio in 1969, with organist Larry Young, guitarist John McLaughlin (who later led the Mahavishnu Orchestra), and the African-American Tony Williams on drums. They played jazz fusion and in 1970 added bassist Jack Bruce of Cream fame. It was this foursome that played at the Minneapolis Labor Temple on April 26, 1970. Little is known about the concert other than that it was so poorly attended that David Anthony pulled out of the venue directly afterwards, due to a large financial loss. Even though Jack Bruce was then one of the world's leading bass players and his name was included in promotion, the group's jazz music was a poor fit for the Temple's normal rock-oriented audience. No reviews of this show have been found.

Illinois Speed Press opened this concert but Ostroushko incorrectly combined the two last words of their name into one: "Speedpress." In fact, this was one of the artist's less inspired designs. The typography and two illustrations are perfectly symmetrical, making for a more static layout than he usually achieved. Normally, he did not place these elements in the center of the poster or balance them equally, side by side. Also draining visual excitement is the minimal amount of color present. The rather lackluster brown ink and yellow stock contribute to this poster falling short of being very psychedelic. The most intriguing part of this example is the Aubrey Beardsley illustration of Merlin the wizard that Ostroushko utilized. It presents the magician as a proto-hippie, with long hair and a free-flowing robe, encapsulated in a circle, the edges of which he caresses with his feet and one hand. Here, Merlin was somewhere out in nature, as he sits among plants, a tree stump, and a diminutive spider. This orb was the clear focus of the poster, due to its being printed in fire-engine red, a fate shared only by the little Pig Puppy Press logo below. This was the last poster that Ostroushko designed for a Labor Temple show that actually occurred.

Labor Temple
presents

Tony Williams Lifetime
with Jack Bruce
and
Illinois Speedpress

117 4th St.
S.E. Mpls.
Sun.
April 26

Tickets
6:30 Show – 3.50
9:30 Show – 4.00

Dayton's – Discount records – Electric Fetus
Dinkytown 521 Cedar

Old Laughing Lady Optic Nerve
1677 Grand·St. Paul 1431 W. Lake

Lights
by Nova
2 shows:
6:30 pm
9:30 pm

MAY 3, 1970 [MLT35]
BUFFY SAINTE-MARIE
SORRY MUTHAS
Lights by Nova
Poster by Juryj Ostroushko
Offset lithograph, 17 x 11 1/16 inches

This concert did not happen, as promoter David Anthony had lost so much money on the previous week's show that he withdrew from the Labor Temple and cancelled the two upcoming shows for which he had booked bands. However, by this time, Ostroushko had already designed and printed this poster for a show to be headlined by Buffy Sainte-Marie (correct spelling). It features an ornate illustration, drawn from an unknown source, with multiple openings and framing devices. Perhaps referring to Sainte-Marie's Canadian Indian heritage, Ostroushko included a nocturnal outdoor scene with a camper and his dog on the left and two bucks on the right under the stars and a crescent moon. While the frame was highly detailed and finished, the image it enclosed was softer and more natural. Similarly, the poster's typography was bright and sharp, while the rest of it featured muted and quiet tonalities. The local jug band Sorry Muthas were supposed to open this show.

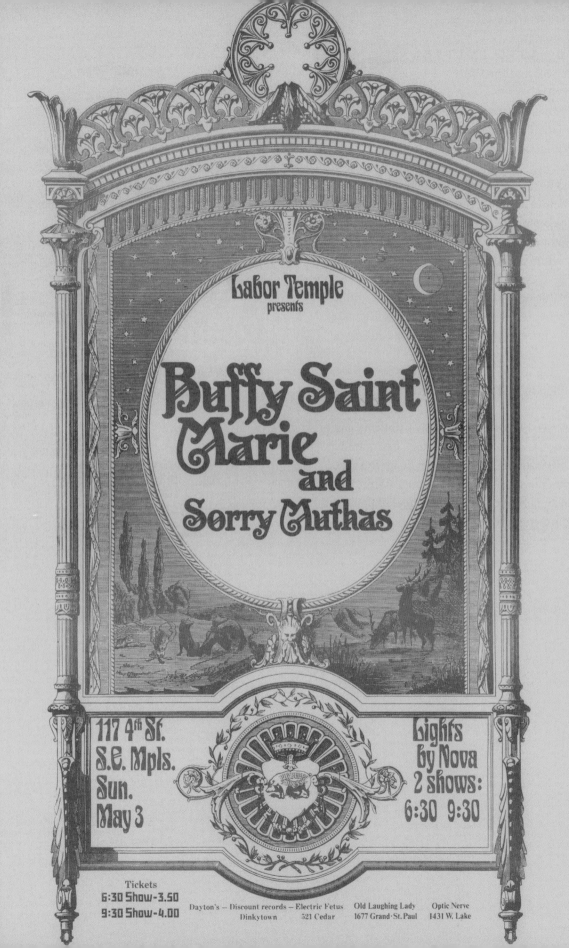

MAY 10, 1970 [MLT36]
COUNTRY JOE and the FISH
PEPPER FOG
Lights by Nova
Reissue poster by Juryj Ostroushko
Digital print, 16 x 11 inches

The second design that Ostroushko had already executed before Anthony cancelled the show was for a return engagement by Country Joe and the Fish. But this one had not gone to press and existed as only a black-and-white stat (fig. 43). It featured an old image of an expansive mountain range, towering over a man in a canoe. Ostroushko used a typeface that mimicked logs for the names of the bands, which reinforced the natural setting pictured. Here we are out in the "country," where there were certainly "fish" in the lake pictured. Local rockers Pepper Fog (two words) were meant to open the concert.

In 2017 Ostroushko decide to finally print this poster, to which he added color. Most notably, he created a sunburst effect in the sky, although he let the sun's rays cascade down into part of the mountains. He also created the appearance of an aged sheet of paper, by providing brown mottling.

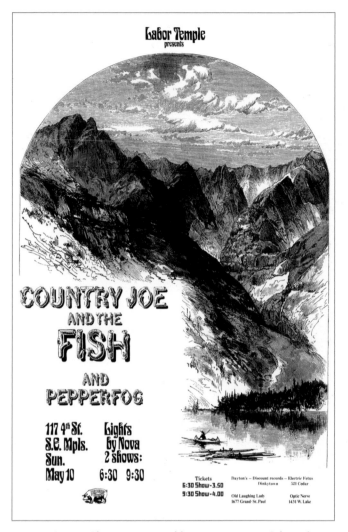

43. Stat designed by Juryj Ostroushko. Country Joe and the Fish.

Labor Temple
presents

COUNTRY JOE AND THE FISH
AND PEPPERFOG

117 4th St.
S.E. Mpls.
Sun.
May 10

Lights by Nova
2 shows:
6:30 9:30

Tickets
6:30 Show - 3.50
9:30 Show - 4.00

Dayton's — Discount records — Electric Fetus
Dinkytown 521 Cedar

Old Laughing Lady Optic Nerve
1677 Grand · St. Paul 1431 W. Lake

SEPTEMBER 13, 1970 [MLT37]
SAVOY BROWN
WHITE LIGHTNING
DAWN
Lights by Nova
Handbill by Tom Brussels
Offset lithograph, 8 1/2 x 5 1/2 inches

This was the first show presented by a new promoter at the Labor Temple, the young Dana Marver, under the name Joint Productions. After David Anthony bowed out the previous Spring, Marver was able to secure a lease with the building and resume shows there in the Fall. Since Savoy Brown was one of his favorite bands, he was able to indulge a personal preference and book them as his debut concert at the Temple.

This was the group's third and final show there and by this time lead singer Chris Youlden had departed. So guitarist Kim Simmonds (still sporting his signature Gibson Flying V guitar) now was also the primarily vocalist, although rhythm guitarist "Lonesome" Dave Peverett also pitched in on occasion. On the night of September 13, the Minneapolis Star considered the 15-minute solo by Simmonds on "Louisiana Blues" to be a "masterpiece," and thanked drummer, Roger Earl, for not playing a long drum solo at any point, believing that they often marred concerts. "Beautiful blue-eyed blues" was how Hundred Flowers characterized the night's music. Marver's financial records reveal the great disparity that could exist between the fees of the headlining, national acts and the local openers. The former received $3,500, while White Lightning, from the Twin Cities, walked away with a paltry $130.

White Lightning was a Cream-inspired trio, named after a strain of LSD. It was formed a few years earlier by guitarist Tom Caplan and bassist Woody Woodrich, both previously in the major local group the Litter. As was often the case with their shows, they played their renowned "White Lightning Overture," an adaptation of Rossini's nineteenth-century "William Tell" opera. However, the Star complained that the band needed some new material, having not added any for a while. Preceding White Lightning at the show was the local acoustic trio Dawn, which included the Temple emcee Ken Schaffer. Their set, apparently mostly of cover songs, featured some by Donovan and Neil Young, to which the crowd enthusiastically sang along.

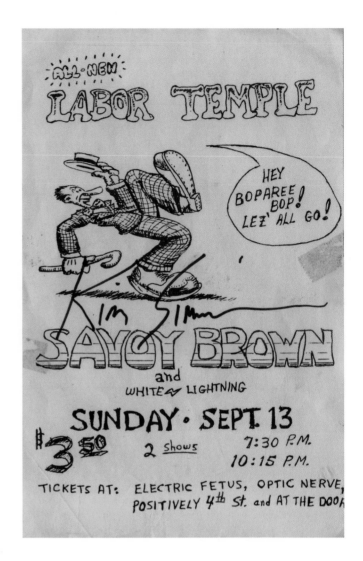

Marver did not issue posters for any of his shows, instead printing just small handbills, like this one. Primitively hand drawn by Tom Brussels, a local musician, they did not compare to the much more accomplished posters by Juryj Ostroushko, a trained artist. The Savoy Brown handbill features a well-dressed, high-stepping cartoon figure, which was undoubtedly inspired by the California comic artist Robert Crumb. Note that the one still in Marver's possession (pictured above) was signed by Savoy Brown's Kim Simmonds.

REVIEWS
Dodd Lamberton, *Guitarist Leads Way,* Minneapolis Star, September 14, 1970, page B5.

Savoy Brown Reopens Temple, Hundred Flowers, September 18, 1970 (vol. 1), page 14.

SEPTEMBER 20, 1970 [MLT38]

GYPSY

PEPPER FOG

Lights by Nova

Handbill by Tom Brussels

Offset lithograph, 8 1/2 x 5 1/2 inches

Gypsy was a band from Los Angeles that had started in the Twin Cities as the Underbeats, led by Jim Johnson (lead guitar), James Walsh (keyboards), and Enrico Rosenbaum (rhythm guitar). The year of this Labor Temple show, they released their first record, a self-titled double LP, which was very unusual, as record companies rarely risked the expense of two discs for a group's initial album. But it garnered two national hits, one of which was "Gypsy Queen." The cover of the record was distinctive for its use of an elaborate, vintage Art Nouveau design by Alphonse Mucha (fig. 44), part of which appears in the handbill. Gypsy played progressive rock and became the house band (opening for major acts) at the Whisky a Go Go, the renowned music club on Sunset Boulevard in West Hollywood.

The one review of Gypsy's concert at the Labor Temple, in Connie's Insider, observed that the band combined acid rock instrumentation with vocals of "interesting harmonies and clear melody lines." Still, it found their music neither challenging nor particularly distinguished from that of other groups. Gypsy was something of a hometown group and the audience gave it a warm reception. Pepper Fog, who had played the Temple two times in 1969, opened the show.

The work of Alphonse Mucha was frequently referenced or used wholesale by the psychedelic poster artists in the late 1960s. The piece seen on Gypsy's album and in the Labor Temple handbill was his 1896 lithograph "La Plume." It depicts a woman in profile with flowing, stylized hair and a heavily bejeweled head piece. Surrounding her are signs of the zodiac, although in the concert handbill they were replaced by the words "Labor Temple." The concert ticket used this same design, while a newspaper ad reproduced the cover of the record.

REVIEW

My Pop, Connie's Insider, October 10-17, 1970 (vol. 3), pages 14-15.

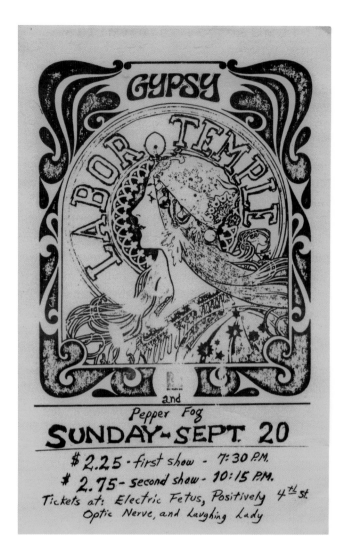

44. Cover of Gypsy album, 1970.

SEPTEMBER 27, 1970 [MLT39]

JOHNNY WINTER

BIG ISLAND

Lights by Nova

Handbill by Tom Brussels

Offset lithograph, 8 1/2 x 5 1/2 inches

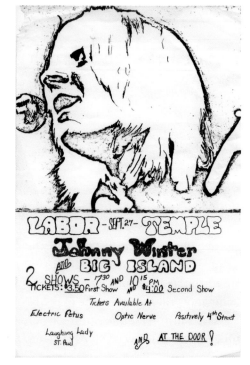

Opening for Johnny's Winter's second time at the Labor Temple was the local jazz-rock group Big Island. Fronted by a good lead singer/conga player, it delivered a "slick" set of originals, which were well received by the crowd. Connie's Insider wrote that they used "complex rhythm and tempo changes for an unpredictable sound." It complimented them on the way they built up instrumental intensity, but lamented that they often slapped a "conventional, garbled finish" onto their songs.

After Big Island, Johnny Winter (fig. 45) started late because his equipment was delayed. But once he strapped on his Gibson Firebird, he dove into two songs from his new album "Johnny Winter And." The "And" referred to Winter's new backup musicians, comprising guitarist Rick Derringer, bassist Randy Jo Hobbs, and drummer Randy Zehringer, who as the McCoys created the number one hit "Hang on Sloopy" in 1965. At the Temple, they followed up their new songs with some slow blues numbers.

Unfortunately, Hundred Flowers found that during Winter's first set both the performers and the audience were "tired and bored, insincere in enthusiasm and uninspired." It then noted that the group's second show was "outrageously short," with the audience seemingly demanding an ovation just so they could get their money's worth. Connie's Insider observed that "at times, the Winter concert seemed to be a public jam session, with the performers oblivious to the length of the pieces and, perhaps intentionally, ignorant of the electrical and logistical problems of the evening." Reportedly, the audience was rather quiet, except when they recognized a previously recorded song.

Despite the apparently compromised music, financially this was promoter Marver's most lucrative show, a sell-out. Though he had to pay Johnny Winter more than any other act he booked at the Temple ($4,000), he grossed about $10,000. Marver remembers that after the show Winter was too "junked out" to even read the menu at the restaurant to which they had retired.

The handbill for this show features a photographic close-up of Winter, singing into a microphone with his eyes closed. Artist Brussels used a solarized effect on the image, to give it a ghostly quality and emphasize Winter's long hair. Equally effective was the newspaper ad for this show, which also used this photograph. Here, however, it is presented as both a negative and positive image, with one flopped horizontally, to suggest that Winter was singing back to himself.

REVIEWS

Jim Gillespie, *Second (Rate) Winter,* Minnesota Daily, October 2, 1970, page 21.

My Pop, Connie's Insider, October 10-17, 1970 (vol. 3), pages 14-15.

Tom Utne, *Winter,* Hundred Flowers, October 2, 1970 (vol. 1), page 15.

45. Johnny Winter performing at the Labor Temple.

OCTOBER 4, 1970 [MLT40]

SHA NA NA

MYSTICS

Lights by Nova

Handbill by Tom Brussels

Offset lithograph 8 1/2 x 5 1/2 inches

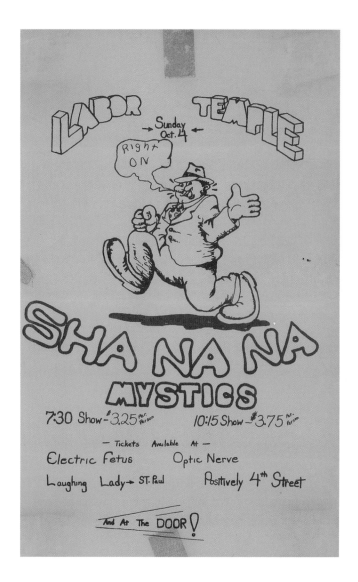

Sha Na Na swung into Minneapolis with its typical 1950s rock'n'roll revival show in the Fall of 1970. Made up of a full dozen performers, it included individuals playing the guitar, bass, organ, drums, saxophone, and a lead vocalist. Supplementing the musicians were six male dancers, three dressed as greasers and three in sparkly, platinum-studded jumpsuits. The former were decked out in tight pants, white socks, pointed black shoes, t-shirts, ducktail hair, and sideburns.

These dancers provided constantly entertaining choreography, with hands, arms, and legs, and "tear-jerking theatrical gyrations." The Tribune reviewer wrote, "Every move they made was polished to perfection and executed with precision. While the instrumentalists might content themselves with a few steps in unison, the lead singer would writhe with emotion and roll on the floor, while three others in matching gold lamé suits dance madly together." The songs the group played were a combination of vintage covers and originals. Among them were "Chantilly Lace," "Teen Angel," "Get a Job," and Jerry Lee Lewis' "Whole Lotta Shakin' Goin' On." The band finished the show with "Rock'n'Roll Is Here to Stay" and "Lovers Never Say Goodbye."

Preceding Sha Na Na were the Mystics, a local mixed-race horn band, appropriately enough with a 1950s sound. They had begun as Michael's Mystics (named after the leader Mike Stokes), and in the late 1960s won a number of Connie Awards, doled out annually by the local music magazine Connie's Insider. Two nostalgic musical acts was a somewhat unusual bill for the Labor Temple crowd and the sparsely attended second show put the books for this show in the red.

The handbill for this show presented a high-stepping cartoon figure, similar to the one on the handbill of a month earlier, both inspired by the work of Robert Crumb. This time, he waves "hi" and quips "Right On."

REVIEWS

Scott Bartell, *Sha Na Na Plays at Labor Temple,* Minneapolis Tribune, October 5, 1970, page 23.

Ron Dachis, *Sha Na Na,* Minnesota Daily, October 9, 1970, page 11.

OCTOBER 11, 1970 [MLT41]

POCO

JARREAU

Lights by Nova

Handbill by Tom Brussels

Offset lithograph, 8 1/2 x 5 1/2 inches

In 1968, when Buffalo Springfield broke up, Richie Furay and Jim Messina moved on to form Poco, whose sound was now more country-rock than folk-rock. With Rusty Young on pedal steel guitar, they recorded two LPs before this show at the Labor Temple. The dozen songs they played here that night included "A Child's Claim to Fame" and "Got a Good Reason for Lovin' You." Their acoustic set featured bright guitar work and tight vocals, often in "pretty-as-a-picture" three-part harmonies. Hundred Flowers found the band members to be "energetically kind, sweet, humble, and united." Their electric set, on the other hand, was reviewed as consisting of "dull, drawn-out" songs that were "painfully" loud.

The opening act, Jarreau, was a small group fronted by none other than Al Jarreau, when he briefly lived in the Twin Cities. It included some members of Zarathustra, who had played the Temple the year before with the Jeff Beck Group. Jarreau had formed the group just a few months earlier and that night they played five songs, two of them originals. The Minnesota Daily felt that the singer rivaled Joe Cocker in inventiveness and the Tribune heard "fantastic percussion and instrumental mimicry with his voice."

The handbill for this show used the very same design of the one from the previous week, simply altering the date and band names. The ticket design was equally uninspired (fig. 46)

REVIEWS

Scott Bartell, *Poco Plays Concert at Labor Temple,* Minneapolis Tribune, October 12, 1970, page 31.

Dodd Lamberton, *Concert Not Poco's 'Schtick',* Minneapolis Star, October 12, 1970, page B4.

Carrie Storley, *Poco,* Minnesota Daily, October 16, 1970, pages 19-20.

Poco, Hundred Flowers, October 16, 1970 (vol. 1), page 10.

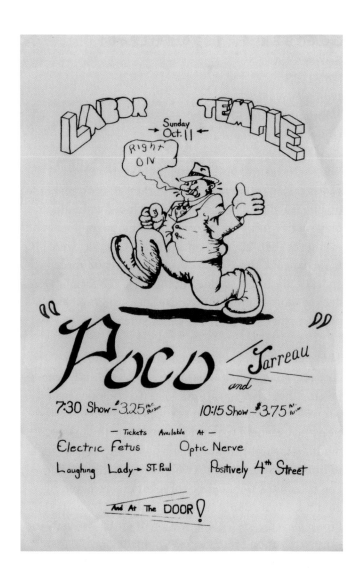

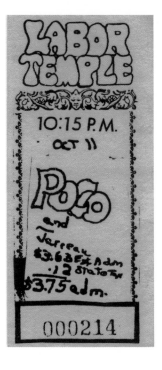

46. Ticket for Poco show.

OCTOBER 25, 1970 [MLT42]

BROWNSVILLE STATION
NIGHT TRAIN
PUBS
Lights by Nova
Handbill by Tom Brussels
Offset lithograph, 8 1/2 x 5 1/2 inches

The MC5 were scheduled to headline this concert but they cancelled so late that the handbill and newspaper ad (fig. 47) still listed them. According to promoter Marver, the band simply didn't want to come all the way from Detroit and had no other shows booked along the way. Consequently, Brownsville Station, the original opener, moved up the bill, and the Detroit group Night Train was added.

Brownsville Station formed in Ann Arbor, Michigan, in 1969, and the next year released its first record, "No BS," the initials of which presumably stood for either Brownsville Station and/or bullshit. The group went on to record the top-ten hit "Smokin' in the Boys Room" in 1973.

No reviews of this show have been found, except for the following sentence that was scrawled across the bottom of a page in Hundred Flowers: "The MC5 didn't show at the Temple but our spies reported Brownsville Station and Mainline were OK." It is unknown who Mainline was, but Marver's own group, the Pubs, also played that night, opening with a 30-minute set. Marver lost the 50% deposit he had paid the MC5, and this was the beginning of financial concerns for him at the Temple. The handbill for this concert is perhaps the least satisfying of them all.

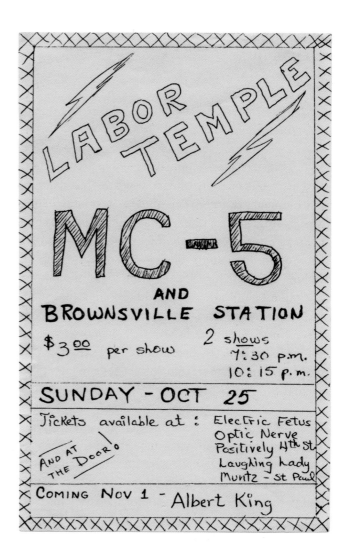

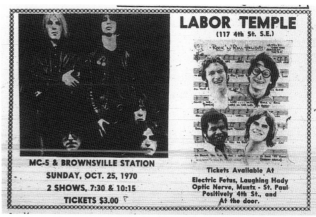

47. Newspaper advertisement for MC5 concert.

NOVEMBER 1, 1970 [MLT43]
ALBERT KING
SORRY MUTHAS
Lights by Nova
Handbill by Tom Brussels
Offset lithograph, 8 1/2 x 5 1/2 inches

Previously, the Labor Temple had tried to present the Southern blues guitarist Albert King two times, but finally landed him in the Fall of 1970. Best known for his 1967 single "Born Under a Bad Sign," King was an imposing figure, six and a half feet tall and weighing in at around 250 pounds. On stage, he dwarfed both his five-man band and his Gibson Flying V guitar, making it look like a child's toy. Along with his signature song, King played at the Temple "Stormy Monday," "Ain't Got Nothin' on Me," "I Think I'm Drowning on Dry Land," and "Crosscut Saw." He began and ended the show with up-tempo instrumentals that showcased the talents of his band.

On stage King was a taskmaster, giving band members a dirty look if they made a mistake and even yelling at them "$10," the fine he collected from them afterwards (a practice he picked up from singer James Brown). Though the audience was modest in size (perhaps due to his reputation for not showing up at concerts), he managed the crowd adroitly with his singing and playing. For instance, when he broke a guitar string, he didn't stop cold, but, rather, rapped about the meaning of the blues, saying, "The blues is when a baby is in his crib and he's getting hungry and gets to wanting his bottle and there's nobody around. Man, that baby's got the blues, just like you and me."

The Minneapolis Star characterized the show by stating, "King's guitar style is similar to that of an arch-rival, B. B. King, but Albert's is more powerful, completely dominating his band, while B. B. tends to hang back and just play short, sophisticated breaks. Albert also tunes his guitar lower, allowing him more freedom to bend the strings and produce the exaggerated slurred notes for which he is famous. The resulting sound is a harsh, biting wail that cuts right through."

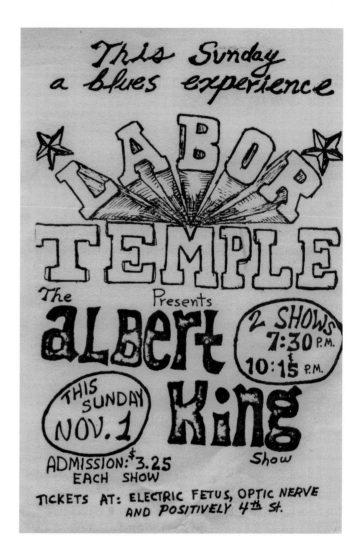

Opening the show was Sorry Muthas, who presented a traditional country, "down-home" set of songs with dobro, washtub bass, fiddle, banjo, mandolin, mouth harp, guitar, and spoons. For the second week in a row the handbill included no visual imagery, but promised "This Sunday, A Blues Experience." Strangely, the word "Labor" received more emphasis than did the name of the performer.

REVIEWS
Jim Gillespie, *The King is Alive—So Are the Blues,* Minneapolis Star, November 2, 1970, page 19.

Jim Gillespie, *Albert King,* Minnesota Daily, November 6, 1970, pages 20-21.

John O'Brien, *Albert King,* Hundred Flowers, November 6, 1970 (vol. 1), page 15.

NOVEMBER 8, 1970 [MLT44]

ALICE COOPER
AMBOY DUKES
Lights by Nova
Original artwork, 8 1/2 x 5 1/2 inches

No original handbills have been located for this show, so in 2018 Marver commissioned an artist to recreate one after his memory of it. For a third time, the "Right On" man was used.

Unbeknownst to Marver, this would be his last show at the Labor Temple (see main essay for discussion). By the time the Amboy Dukes pulled into Minneapolis, they had released four albums, with leader Ted Nugent writing and singing most of the songs. This was another loud concert, with Nugent at one point screaming "at peak lung power" and playing his guitar at over-amped volume. The band was also into physical antics that Hundred Flowers found were sometimes arrogant, forced, and distracting from the successful guitar work and bouts of feedback. The newspaper reported that they "did manage to work up their the-atrics to the point where quite a few bodies and minds were squirming in the intensity. Nugent went through some very tight hard sessions, relying mainly on his guitar playing to work up the audience's enthusiasm, then his theatrics became more insolent and intense, and his guitar playing becoming more a part of his whole theatrical effect as the set progressed." Marver's most vivid memory was of Nugent jumping off of his amplifier, wearing a Tarzan-like outfit, without any underwear.

Alice Cooper, back for their second time, shared the bill with the Amboy Dukes, each band headlining one of the shows. Performance was such an integral part of their set that it prompted Hundred Flowers to title its review of the evening "Post Halloween Freak Out."

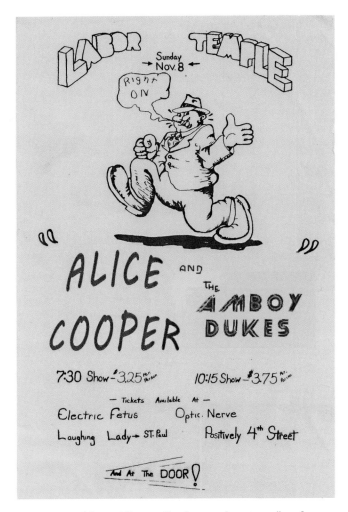

It recounted how Alice walked onto the stage "gayly swishing," to give the audience a limp-wristed wel-come wave, and then used props such as strobe and flood lights, and a blue screen door (for a piece about Marlene Dietrich). Among the songs played were "Drag-Queen Bitching" and "18," during which Alice teased and scowled at the crowd. They ended with what was characterized as a "sardonic musical sketch," with Alice wrapped in a sheet, holding a devil's scepter overhead. And with that flamboyant flare, the Sunday-night dance concerts at the Minneapolis Labor Temple came to an abrupt close.

REVIEW
Post Halloween Freak Out at the Labor Temple,
Hundred Flowers, November 12, 1970 (vol. 1), page 13.

COSMIC TRIP

MINNEAPOLIS LABOR TEMPLE 1969-70

INTERVIEW WITH JURYJ OSTROUSHKO

by Paul Pashibin, July 10, 2018

As I sit across from Juryj at this Perkins restaurant, I see the same tie-dyed shirt and grey pony-tail, the same spark in the eye, and the same spirt of a man that I met nearly three years ago in this exact same spot. I had reached out to a friend of mine named Kevin Odegard—yes, the same Kevin who played on Bob Dylan's record "Blood on The Tracks." Kevin told me about this guy named Juryj who was a graphic artist and poster artist from the 60's in the Twin Cities. As a 15-year collector of rock posters, with deep friendships with artists like David Byrd, Arnold Skolnick and Bob Masse, I needed to meet Juryj and learn of his art. We arranged a meeting where he brought his portfolio of art, including originals from most of the shows at the Minneapolis Labor Temple. A portfolio that Juryj contemplated throwing in the trash a dozen times over the last 30 years. During that first meeting, I learned about Juryj, his passion for music and art, and his roots as one of the first West-Bank hippies. We talked about his volume of work and there was one point in the conversation I leaned into Juryj and stated, "This needs to be a book. Your story, your art. We need to tell everyone." Over the next three years, we conversed. I sold a few of his posters in my auctions and I purchased a few to complete my collection. And I eventually introduced him to Christian Peterson, who ended up agreeing to write the book. Juryj and I sat down for an interview for this book.

— Paul Pashibin

EARLY YEARS

I was born in Zams, Austria, in 1949, to Ukrainian parents, Wasyl and Katerina, refugees of World War II. Two years later, when we came to America, my name was changed at Ellis Island. As there was no translation for Juryj (pronounced "YOUR-e"), my parents, not understanding English, agreed to George. We first landed in Minneapolis on Nicollet Island because my Dad, in his youth, had read "Huckleberry Finn" and decided that if the Mississippi River was good enough for Huck Finn it was good enough for the Ostroushkos. A few years later we moved to lower Northeast, just shouting distance from the Labor Temple, the future home of my creative beginnings. We spoke our native language at home and I remember taking Saturday classes in Ukrainian history and culture. Northeast Minneapolis was a melting pot of ethnic peoples—Native Americans, Poles, Czechs, Ukrainians, Lebanese, and others. We learned from each other's cultures and drew strength from our differences.

Having grown up in a musical family, I decided at 15 that music was my calling, so my 12-year old brother, Peter (who would eventually become a world-renowned stringed

musician) and I formed a band and started to follow our musical dreams. In fact, our last name means "sharp ears" in Ukrainian. But, something happened along the way to change my life and I realized that although music was my love, art was my passion. So I followed my passion.

HEADING TO SAN FRANCISCO: THE SUMMER OF LOVE

It wasn't my idea to go to San Francisco. I'm a home-body and I don't like to travel. I had a guru hippy friend who bought me a ticket anyway. I was just a 17- year old kid. Growing up in Minneapolis, my brother and I were already into the music scene. We were listening and knew about bands, from local to San Francisco, before almost anyone else around us. That's when I started collecting LP records, most of which I still have today. I knew about Moby Grape before their record even hit Minnesota. And my dream was to be part of that music scene; it was not about poster art. The summer of love was happening, the whole world was changing, and we had already bought into it. When my friend came to me and said, "Do you want to go to San Francisco?" my first thought was "Absolutely!" I wanted to be a musician. That's where you go to become a musician. My second thought was, "Do I really want to leave home to do that? Can't I do that from here?" I was a little afraid. As most 17-year old kids, we liked to pretend we were brave and bold and we were going to go tackle the world, but that was not me. I went for the music.

When I hit the streets of the Bay Area, and found out that many, many people were there to be in a band, I soon realized that my chances of success were slim. My music performances were with people I met in the streets, not on the stage. I spent time making sketches and actually selling some, doing random art, and attending shows and watching how the productions were made, including the light shows.

SAN FRANCISCO IN 1967

I was homesick the whole time I was there. By late 1967 it was already a mess. You could walk down any block and the kids were sitting on the boulevard, hundreds, thousands, asking for handouts. You could easily find all the drugs you wanted and a place to crash—that was not a problem—but you didn't know if you were going to wake up robbed or alive the next day. It was not like Minnesota. We had a safe haven here. I decided early

along that I was not going to stay there. But what kept me there was the fact I could go to the Carousel, or Fillmore, or Longshoreman's Hall, down to the Panhandle, and just listen to music, all the time. I had known about these places from reading about them and was familiar with their posters. Three bands I saw early on were Procol Harum, Country Joe and the Fish, and the Daily Flash. Where I saw them and in what order I'm not sure. I was at the Fillmore two or three times, and I went to more shows at the Avalon Ballroom and Matrix club. I enjoyed those two venues more and I got to know folks who worked the doors and they got me in for free. The vibe at the Avalon was more to my liking. Typically, I went where the cats I hung with went. My financial situation dictated everything. In hindsight, if I had planned my visit to the Haight better, I would've brought a bigger bankroll to see more of the bands. The measly money I made by selling drawings in the Panhandle or on the streets was barely enough to eke out a living, let alone for entertainment. But what an experience, and, I will tell you, those concerts changed my life.

One of my favorite poster artists was Rick Griffin. I love his lettering; the more creative the better. The main place the kids went to along the strip was called the Drogstore, a combination diner and coffee house. It was mostly your beatniks drinking coffee and one section was folks coming for their morning newspaper and having breakfast. It was one of the most popular places because it was cheap as hell.

[Interviewer's note: The Drogstore was first called the Drugstore Café, but changed its moniker after the California pharmacy board objected to its name. The location appeared in the 1968 cult movie "Psych-Out," about the Haight, starring Jack Nicholson as a hippy who befriends a deaf runaway.]

On any day you might find Wes Wilson or Stanley Mouse in there with their sketchbooks. I did a lot of work there too. It was in these community places and on the streets where we shared ideas and I know I picked up influences from these artists. I like to think I influenced them as well. You never knew where these sketches were going to go or what they would be used for. I ended up staying in San Francisco from November 1967 through April of 1968. I never knew I would come back to Minnesota and use these influences to create posters for some of the top musicians in the world at the time.

THE NEXT CHAPTER: DESIGNING TYPEFACES

When I got back to Minneapolis I lived with some friends near the Minneapolis College of Art and Design. By then my brother was playing with a group called the Mill City Blues Band. I saw the hard work they put into their music and I was nowhere near their skill level. Music looked like a long hard road to travel, and I knew my opportunities were limited. Previously I had attended the vocational-technical high school, where I got turned on to graphic design. And I found a passion for art while sketching and doing odd jobs in San Francisco. After returning I got a job at Headliners, the largest type developers in the world. In those days companies had their ads done manually if they wanted a professional looking job. We had relationships with some of the top ad agencies in the world, such as Campbell Mithun and Carmichael Lynch, and if they were designing professional ads for newspapers or catalogs they came to Headliners. There they had choices of thousands of fonts.

At this time I had started designing posters for the local music venue, Dania Hall. I showed some of them to an older, fellow employee, Eddie Harris, and he thought that the typography was too hard to read. I said, "You're right! They're supposed to look that way, as if you were on hallucinogenic drugs." He then suggested that perhaps he and I could design a typeface similar in style, but that it had to be more legible, for commercial use, so our customers would use it in their ads to sell products. So, I agreed, and Eddie did drawings of all the individual characters in the alphabet. Half of them I thought were fine, but the rest I altered so that they would flow better. And that's how we created what, appropriately, was named "Psychedelic." By the way, we didn't ever get credit for or own any rights to that or any of the other typefaces we designed while employed at Headliners. We got paid our hourly rate, and I was able to use some of the facilities and materials of the business when I worked on posters for both Dania Hall and the Labor Temple.

JURYJ'S FIRST AND SECOND POSTER

I met a fellow hippie named Charlie Campbell by happenstance at the original Electric Fetus record store on Cedar Avenue, near the University of Minnesota.

[Interviewer's note: The Fetus, now located on Franklin Avenue at the 35W interstate overpass, is one of the longest-lived record stores in Minnesota and perhaps the entire country.]

He needed someone to design a logo and he asked me to stop by his shop called The Leatherhead on East Lake Street. I ended up designing the logo for his shop. We each went to San Francisco separately and got back about the same time. That same month that we got back, Charlie contacted me to do some work on a poster for a concert on the West Bank. And that was my first poster for a music show. It was more of a hand-bill, for a concert at Dania Hall for a band called Blue Sandelwood Soap. They were a 60's psychedelic garage band and two of the members lived on Nicollet Island. I actually attended the show, with about 150 people there. Charlie gave me three days to complete the poster, and paid me $15 and a couple joints. Everything back then was in trade. You always had joints in your pocket to pay each other off.

My second poster, also for Dania Hall, was for a group called the Nicollet Island Peep Show, a band I had heard only once before. Just last year I met a member of that group and we are in communication today. He told me the whole story about how they lived on Nicollet Island.

ON SAVING HIS PORTFOLIO

Over time I created perhaps 50 posters and handbills for concerts. I have no idea why I saved these posters all these years.

[Interviewer's note: I recall when Juryj called me on the phone, perhaps September of 2016. He declared, "I've found them!" He had located his portfolio containing about fifty original posters from the Labor Temple, a few from Dania Hall, and some original poster art and lettering.]

When my wife and I moved from Minneapolis to the suburbs, I had lots of portfolios of artwork: most from my job at Headliners and of course my original artwork for the Labor Temple posters. They took up space and I had not even opened them for dozens of years, if not more. When we moved I contemplated throwing

everything out. There were times throughout the years when I contemplated cleaning up, and I was inches away from throwing all the items away. I never felt they had value or would be of interest to anyone. Still, to this day I am not sure why I didn't toss them. My wife, Lynn, encouraged me to save them for our kids. And here we are. I don't have all of the posters I did. I recall one for the Paisleys that I've never seen again. I had also saved my sketchbook from San Francisco and used it for inspiration, but lost that over the years. I recall the snake head I used for the Ten Years After poster was taken directly from ideas I had drawn in my San Francisco sketchbook. I wish I had it, but I'm glad I found what I did.

ON COMMUNITY NEWS
Hippies lived like vagabond gypsies back then. I was never officially part of Community News, the organization that promoted concerts. It included Charlie and John Campbell ("Bullet"), Jim Donnelly ("Woody"), Joey Armstrong, and Jim Hanson ("Mooner"). They lived primarily in two locations: a mansion in North St. Paul and in a house in Southeast Minneapolis. I had my niche of people I hung out with. The first true hippies of the Twin Cities were from the university's West Bank. We did meet up at the after-show parties. Like when the mansion burned down the night of the Jeff Beck concert. Then the commune moved out to a farm in Eden Prairie. In the Community News group I did get along with everyone and I ended up helping run the light shows at the concerts. Charlie saw the value in me, a talented poster artist. He knew the posters I did for Dania Hall and I think he wanted that type of work for the Labor Temple, and he knew I had all of those resources at my fingertips. Our relationship was built around mutual respect.

MOVING TO THE LABOR TEMPLE
In December 1968 Charlie and I discussed opening a larger venue in Minneapolis, while sharing some pot. He had not known that I was in San Francisco at the same time he was, and this came out. We had a lot to share and we started talking about a bigger venue than Dania Hall. He thought we could join forces and work to get a possible venue on East Lake Street. I was concerned we needed a place closer to our audience base. I even told him at the time that you know what would be perfect, something near the University of Minnesota. You got the West Bank and the students. There is our base. I also said to Charlie that we were

not going to be able to procure any place. I don't care where it's at. Look at us. No one is going to rent anything to us longhairs. We need a business partner.

We had a concert coming up in December with the Litter. That was the poster I created with the Martian. I said, "Let's invite the manager of the Litter, Dave Anthony, and talk to him. He's a straight guy who wears a suit and tie." Now Charlie was willing to do almost anything to move out of Dania Hall to a larger venue. He ended up inviting Dave to the Litter show. Dave was very impressed with Dania Hall and the light show. They met a few times after that, and something struck up a chord with Dave, because at the last show of the year (the concert by Jokers Wild, who Dave also managed), we learned Dave was on board and currently looking for a place. A week later I met them in Southeast Minneapolis at the Labor Temple. I had never been in that building before and we loved it. As you know, it's torn down now—it's a parking lot. I have recently been inside the Labor Temple's sister building right next door, which is now the Aveda Institute. And it looks very similar to the old Labor Temple, complete with the third-floor auditorium. And of course I'll never forget the amazing concerts we put on there, and I hope the reader of this book will enjoy learning about them. That first Grateful Dead concert (in February 1969), even Charlie will tell you, we were not prepared. We did not know what to do with 2,600 people. We were just 17 and 18-year old kids ourselves, learning as we went. We took a chance. And it was special.

CREATING THE
LABOR TEMPLE POSTERS
Now I was being paid by Dave Anthony to design posters for the Temple. I was going to the university, working full time at Headliners, and doing poster art in what little spare time I had. At first, I designed about ten posters for the weekly Sunday night concerts. They were printed by standard offset lithography, but then things changed with Community News. Member Joey Armstrong asked if his younger brother, Bradley, could print the posters by the silkscreen process, because he had access to equipment at his high school. So, the next half dozen posters (during the Spring of 1969) were done that way, though I still provided the artwork for them. Among the bands featured in these, larger size, posters were Illinois Speed Press, Canned Heat, Deep Purple, and Muddy Waters. Once the concerts resumed, in the Fall of 1969, Dave

Anthony didn't hire me to produce posters, so the only promotional material was newspaper ads. Finally, at the beginning of 1970, Dave reenlisted my services and I did posters for shows by the Small Faces, Youngbloods, Johnny Winter, and other bands. Strangely, my last poster for the Temple was for a Buffy Sainte Marie concert that ended up being cancelled

Dave gave me $100 per poster for designing and a modest printing budget. Working at Headliners made it easy for me to hit the lettering catalog to find something that would enhance the design, set it, and put it on the poster. Finding the images was next. Some were obvious, like a bird illustration for the Byrds poster. I wanted, as an artist, to be as professional as I could under the existing limitations. The very first poster, for the Grateful Dead, was the one I put the most effort into, in part because I had sufficient time. But Dave Anthony objected to the high expense of printing three colors, and subsequent posters were less elaborate and costly. From that point on, I usually used colored paper and only one color of ink. However, occasionally I was able to slip in an extra color, such as for the Buddy Miles Express poster. Dave really didn't see the need for posters. I know that Bill Graham, who ran the Fillmore Auditorium, felt the same way. He argued all the time with Wes Wilson, his poster designer, saying that he couldn't read the lettering, which he thought was counterproductive.

THE ST. PAUL MANSION STORY

I still had my music juices flowing and any time I could be in a situation where I could pull out my harmonica, I loved that. I went to the Pacific Gas and Electric show, which Savoy Brown opened. I was not a fan of PG&E but sometimes you need to spend some time one on one and get to know people. Sitting at the mansion that night (or that morning), stoned out of our heads, both bands started jamming together. They took out all their acoustic guitars. The acoustics in the room of the 1890's home were perfect, with high ceilings. They started jamming blues numbers one after another. I got to see PG&E—not the stage act, but the musicians that they were. There is no question that Savoy Brown was one of the most incredible blues bands of their time. And I got to jam with those people. For a musician to be able to be there and play with them was an amazing experience. We went all night. Those are the moments I remember the most. I'll never forget them.

BEING A GRAPHIC ARTIST AND FAMILY MAN, AFTER THE TEMPLE

In 1971 I left Headliners and then worked in various art studios over the next 30 years, as a designer and art director. Much of my career involved illustrating publications, such as text books, children's books, and history books. For about 15 years I also enjoyed teaching art classes through Dakota County community education. But the job that most directly related to my Labor Temple days was as the first designer/art director for Minneapolis' Red House Records, where during the 1980s I designed about 35 album and CD covers. These included releases by Greg Brown, Bobby McFerrin, Prudence Johnson, and, not surprisingly, my younger brother, Peter Ostroushko. Now, when I'm not recreating my Labor Temple posters, I have a flourishing business in art, as well as painting Lake Superior rocks with butterflies and rock stars.

[*Interviewer's note: Juryj says, with a smile, "You should check them out at juryjart.com"*].

As I've gotten older, I've developed new passions; the environment, Minnesota wildlife, camping under the stars, and just spending quiet time at our beloved cabin in the Boundary Waters. Most important is my family; my wife, Lynn, the love of my life, and my kids: Christopher, Jessica, Laura, Jonathan, Nate, and Michael. They all inspire me to carry on.

ON MY LEGACY

I like to consider myself one of the original hippies from the West Bank. Paul, when we first met, you told me that we gotta write a book. And I had actually been thinking about that for 20 years prior. I was busy with my life then. My kids were in school, and I didn't know that I had time to complete the effort. Now we are here. I feel the timing on this was meant to be, as coming up early in 2019 is the fiftieth anniversary of the first Labor Temple concert and poster. I had met you, and you showed interest in having a show of my posters. You invited Christian, a writer, to the event, and we met. Over this period of time I realized I had wanted to tell a complete history of that period of time, from 1967 to 1970 and the West Bank had to be included. I wanted and needed to include Charlie Campbell and Community News. We did this together.

As work on the book progressed, and more data has come out on the posters and the relationships, I felt that my artwork became an important thumbprint of Minnesota's music history. What I finally realize is that I wanted the book to cover the posters too, not just the story of the people. I'm my own toughest critic, and it was too bad that the frequent time constraints of the situation didn't allow me to be the artist I wanted to be. Now I pick up this book, and go poster to poster. I wish I would have started earlier to issue second editions of my posters. Presently, I'm excited to see these because they reveal what 50 years of experience can teach you. Finally, yes I can say I wish the posters were better, but I hope that the readers who will thumb through this book will discover the historical parts or remember where they were at that moment in time. Ultimately, I want you, the reader, to engage with these posters to allow yourself to step back into that cosmic time when the iconic Labor Temple was the preeminent venue for rock concerts in Minneapolis.

Juryj Ostroushko in 2018. Photograph by Vance Gellert.

Minneapolis Labor Temple demolition, 1975. Photograph by Robert Borchert

ABOUT THE AUTHOR

Christian A. Peterson was a curator at the Minneapolis Institute of Art from 1980 to 2011, where he organized many exhibitions. Among his books are *Alfred Stieglitz's "Camera Notes"* and *After the Photo-Secession: American Pictorial Photography, 1910-1955*. Most relevant to the current project was his 2007 show and catalog *San Francisco Psychedelic,* which included photographs and posters by Jim Marshall, Rick Griffin, and others.

INDEX TO MUSICIANS

Agar, Will . 28, 50

Alice Cooper 24, 25, 90, 91, 105

Allman Brothers 20, 24, 70, 71

Amboy Dukes24, 105

Anderson, Ian 32

Animals . 5

Aorta 16, 48, 49

Baker, Ginger 72

Barnes, Sidney 32

Battin, Skip . 74

Bauer, Joe . 80

Beach Boys . 5

Beatles 5, 19, 64

Beck, Jeff .44

Beck, Jeff, Group . . . 3, 17, 44, 45, 90, 102

Berry, Chuck 5, 62, 72

Big Island .100

Blackmore, Ritchie58

Blackwood Apology 28, 30, 31

Blank, Bob .60

Bloomfield, Michael40

Booker, Gary36

Blue Sandelwood Soap109

Brown, Greg 111

Brown, James104

Brownsville Station103

Bruce, Jack 21, 92, 93

Brussels, Tom23, 98, 100

Buckinghams 13

Buffalo Springfield5, 102

Buford, Mojo 48, 50, 88

Buford, Mojo, Band . . . 3, 48, 49, 88, 89

Butterfield, Paul 14

Byrds 3, 20, 66, 74-77, 111

California, Randy34

Canned Heat 1, 14, 17, 54, 55, 110

Caplan, Tom98

Cassidy, Ed .34

Castaways . 5

Charles, Ray 11

Chase, Scott Richard 80

Checker, Chubby 5

Chicago .48

Clark, Dave, Five 5

Cocker, Joe 21, 102

Cold Duck . 8

Coltrane, John 11

Constanten, Tom12, 28

Cornick, Glenn32

Cotton, Paul56

Cottonwood 62, 63

Country Joe & the Fish20, 82, 83, 96, 97, 108

Cream21, 72, 92

Crow .40

Daily Flash108

David, Kal .56

Davis, Miles 11

Dawn .98

Daybreak72, 73

Deep Purple14, 17, 58, 110

Derringer, Rick100

Diamond, Neil58

Diddley, Bo . 5

Donovan 20, 36, 70, 98

Doors .64

Dr. John 19, 64, 65

Dylan, Bob5, 20, 90, 107

Earl, Roger 72, 98

Electric Flag40

Ellington, Duke 11

Evans, Rod .58

Faces .21, 90

Farner, Mark68

Ferguson, Jay34

Fever Tree 88, 89

Fifth Avenue Band 84, 85

Finnigan, Mike54

Flash Tuesday 68, 69

Ford, Tennessee Ernie86

Furay, Richie102

Garcia, Jerry 12, 28, 30, 52

Gent, Bill .68

Glover, Tony 5, 34, 82

Golden Earring . .20, 25, 66, 67, 84, 85

Goldstreet 58, 59

Grand Funk Railroad20, 68, 69

Grateful Dead3, 7, 12-15, 17, 25, 28-32, 52-54, 72, 110, 111

Guthrie, Woody82

Gypsy 23, 98

Haley, Bill, and the Comets . . 5, 72, 82

Hallquist, Billy86

Hammond, John70, 71

Hart, Mickey12, 17, 28

Havens, Richie50

Hendrix, Jimi 60, 72

Henry, Robb44

Herman's Hermits 5

High Spirits 7

Hite, Bob .54

Hobbs, Randy Jo100

Holly, Buddy 5

Hooker, John Lee 64, 65

Hopkins, Nicky44

Huber, Pete 10, 36, 68

Hunter, Robert 7

Illinois Speed Press14, 48, 56, 57, 92, 93, 110

Inhofer, Gregg60

Iron Butterfly60

James, Tommy, and the Shondells . . 13

Jarreau .23, 102

Jarreau, Al23, 102

Jefferson Airplane5, 50

Jethro Tull17, 32, 33

Johnson, Denny 10, 36, 44, 68, 90

Johnson, Jim99

Johnson, Prudence 111

Jokers Wild 3, 10, 11, 15, 17, 36, 40, 44, 59, 68, 90, 110

Kane, Jim . 23

Keller, Dennis 88

King, Albert14, 17, 18, 23, 59, 104

King, B.B. 11, 21

Kingsmen . 5

Knight, Lonnie10, 36, 59, 68

Koerner, John5, 44, 48, 49

Kosser, Bobby 20, 66-69

Kramer, Wayne62

Kreutzmann, Bill12, 28

Landes, Rob 88

Lane, Ronnie90

LaSalle, Lynn72

Lee, Alvin .46

Lesh, Phil 12, 28, 30

Levinger, Lowell 80

Lewis, Jerry Lee72, 101

Libby, Dennis30

Litter10, 17, 23, 46, 98, 110

Lord, John .58

Lovin' Spoonful84
Lyle, Bobby, Quintet14, 52
Madison, Peewee50
Mahavishnu Orchestra92
Mainline103
Marauders 19, 60, 61
MC519, 62, 63, 103
McCoys .100
McDonald, Joe82
McFerrin, Bobby 111
McGuinn, Roger74
McKernan, Ron ("Pigpen") . . 25, 28-32,
52-54, 110, 111
McLaughlin, John92
Melton, Barry82
Menten, Dale30
Merchant, Ron60
Messina, Jim102
Michael's Mystics101
Miesen, John60
Miles, Buddy40
Miles, Buddy, Express . . . 17, 40, 41, 111
Mill Cities Blues Band 8, 109
Moby Grape108
Monkees .5
Moore, Albert78
Mother Earth 16, 34, 35
Mothers of Invention 14
Muddy Waters 5, 14, 17, 48, 50,
51, 70, 72, 78, 88, 110
Murphy, Willie5, 44, 48, 49
Musselwhite, Charlie64
Mystics .101
Nelson, Tracy34
Nevins, Nancy 50, 78
Nicollet Island Peep Show 9, 109
Night Train103
Noah's Ark8, 9
Nugent, Ted24, 105
Odegard, Kevin107
Olivers .64
Olson, Alan54
Ostroushko, Peter . . . 14, 62, 107, 109, 111
Pacific Gas & Electric14, 15, 17,
20, 25, 42, 43, 58, 59, 66, 67
Paisleys8, 110
Pandemonium Side Show8
Parsons, Gene74
Pepper Fog19, 59-61, 65, 96-98

Peverett, Dave98
Place, Ian58
Poco23, 102
Poison Bird Pie8
Presley, Elvis5, 62
Procol Harum 17, 36-39, 108
Pubs .103
Rascals .84
Rave-Ons40
Ray, Dave 5
Reed, Lou 65, 74
Riperton, Minnie 17, 32
Rolling Stones5, 78
Rosenbaum, Enrico99
Rotary Connection17, 32, 33
Rovin' Kind56
Rugbys .82
Sainte-Marie, Buffy 94, 95, 110
Savoy Brown 3, 15, 23, 25,
42, 43, 59, 72, 73, 98, 111
Schaffer, Ken20, 23, 74, 98
Serfs 14, 54, 56, 57, 64, 65
Shadows of Knight 5
Sha Na Na23, 101
Simmonds, Kim 42, 72, 98
Simper, Nick58
Skin Trade17, 59
Small Faces90, 91, 111
Smith, Fred "Sonic" 62
Smith, Freddie54
Sorry Muthas94, 95, 104
South 40 .40
South, Joe58
Southwind20, 78, 79
Spirit 14, 16, 34, 35
S.R.C. 80, 81
St. John, Powell34
Stewart, Rod21, 44, 90, 91
Stillroven48
Stokes, Michael101
Stone Blues 19, 60, 61
Strength, Bob60
Strength, Dale 60, 90
Supremes 5
Sweetwater 14, 20, 50, 78, 79
T.B.I. (True Blues, Inc.)8, 9
T.C. Atlantic8
Teegarden & Van Winkle . . . 74, 75, 77
Teegarden, David74

Temptations 5
Ten Years After 17, 46, 47, 110
Thundertree 19, 60, 61, 86, 87
Trashmen5, 13
Triad 64, 65
Trower, Robin 36, 38
Tucker, Maureen65
Turtles . 5
Tyner, Rob62
Underbeats99
Valenti, Dino 80
Van Winkle, Skip74
Velvet Underground19, 65
Vestine, Henry54
Walsh, James99
Weir, Bob12, 28
White, Clarence74
White Lightning98
Who .5, 30
Williams, Hank78
Williams, Tony92
Williams, Tony, Lifetime 21, 92, 93
Winter, Edgar86
Winter, Johnny3, 20, 23, 25,
86, 87, 100, 111
Wood, Ron 44, 90
Woodrich, Woody98
Yardbirds5, 64
Youlden, Chris 42, 72, 98
Young, Jesse Colin 80
Young, Larry92
Young, Neil98
Young, Rusty102
Youngbloods 3, 20, 80, 81. 111
Zappa, Frank90
Zarathustra 44, 102
Zehringer, Randy100
Zombies . 5